LIFE'S RICH TAPESTRY

A Plain Man's Guide to the Origins
and Unexpected Consequences of the
Nation State and Religious Faith

Derek G Potter

authorHOUSE®

AuthorHouse™ UK Ltd.
500 Avebury Boulevard
Central Milton Keynes, MK9 2BE
www.authorhouse.co.uk
Phone: 08001974150

First published by AuthorHouse 03/15/2011

ISBN: 978-1-4567-7310-6

Note:

Details of the 11th Century Bayeux Tapestry shown on the cover are by special permission of the City of Bayeux.

The Bayeux Tapestry is a misnomer. It is neither a tapestry, nor was it made in Bayeux, where it is on display. It is an embroidery and is believed to have been woven in Canterbury by the maids and the monks of Kent. It is seventy metres in length and one of the greatest marvels of the mediaeval age. It records the last successful invasion of England by William of Normandy (known as "The Conqueror") one thousand years ago and the start of English civilisation.

References:

I have broken no new ground, but I have tried to see the whole spectrum of the history of mankind from a new perspective. Apart from my personal experiences, every statement that I have made can checked on the Internet, in the *Bible*, *The Encyclopaedia of Mythology*, *The March of Folly* by Barbara Tuchman, the *Rubiayat of Omar Khayyam* and *The Golden Bough* by Sir James Frazer.

I have used quotations from poems I remember having learnt during my education which seem to be apposite, in an attempt to understand the immense distance between the past and our twenty-first century lifestyle, to get into the mindset of a person whose rate of travel was only at the speed of the horse and had been so for many thousands of years, as Shakespeare's was.

I could have filled the book with quotations from Shakespeare, whose understanding of all aspects of life was so acute that he could have been writing today. But I will content myself with one only, from Julius Caesar:

> *There is a tide in the affairs of men,*
> *Which, taken at the flood,*
> *Leads on to fortune.*
> *All the voyage of their lives*
> *Is bound in shallows and miseries.*

No one believes in fairies any more, but we would all be the poorer without Oberon, "Ill-met by moonlight, proud Titania", Puck and Bottom in *A Midsummer's Night's Dream* – and without seeing our children's reactions to a performance of *Peter Pan* by J. M. Barrie.

I have drawn much inspiration from two TV documentaries, *Civilisation* by Kenneth Clark and *The Ascent of Man* by Dr. Jacob Bronowski, both of which were produced by David Attenborough, the head of the then newly created programme BBC Two – the first to be broadcast in colour. I doubt very much whether any of those three people were religious in any true sense of the word.

In particular Bronowski, although he was Jewish by birth, gives an immensely erudite analysis of Darwin's theory of evolution, *The Origin of Species*, which clearly demonstrates that he was agnostic at the very least. However, even as recently as 1966, the BBC was not able to hint at that possibility. The "Elephant in the Room" syndrome was apparent to everyone who saw the series.

Are the times much more different now? We shall see.

Introduction

The warp and weft of the tapestry of human life are so perfectly interwoven that it is impossible to appreciate its design, colour or raison d'être at close quarters. Only in the fullness of time and by standing well back, as one must with the Bayeux Tapestry, is it possible to see the whole picture for what it was, realistically.

Every man's life is a complex mosaic, the result of the intermingling of ideas, people and events, from our first day of life until our death. We learn from them all. Each has had its part to play in the formation of yet another human being. The human brain is remarkable in being able to recall with clarity, minute details of events which appeared at the time to have been of small importance, but which proved to be fundamental.

This book is written for my descendants, perhaps in the twenty-second century, who will then be in a better position to say whether my views turned out to be reasonably correct. I should have enjoyed reading a book by my great-great grandparents of their lives in Victorian times. Most people then were largely unaware of the many things which were happening around them, but perhaps they knew more than previous generations had done – as we now do.

For thousands of years, certainly from before the advent of the Egyptian and Greek civilisations, mankind has been on an endless quest in search of his identity. Everyone wishes to

know from whence they came and to where they are going. It has been endless until now, because such knowledge can only be achieved by detailed scientific research as to man's past. Such research was not available to the ancients and has been specifically discouraged by religious authorities since they have come to power. They wish to maintain their influence over their adherents and do not allow questions to be asked, which would imply that the certainties that they preach, might be incorrect. During certain epochs, man believed he had found the answer, only to discover other information that he gathered later, showed that his hypothesis was false. Nationality and religion have been part of the tapestry for the last five thousand years and have provided a somewhat insecure framework for the social advancement of differing peoples during that long period.

Now is the time for further advances to be made in that quest.

I shall attempt to show that "faith in a divine being" was originally an important, almost crucial, basis for the survival of Homo sapiens. It provided man with a belief that he could exercise a change in his circumstances by appealing to forces (whether towards one god or to many), which had that power. This faith gave him the confidence he needed to survive against all odds. It became an essential part of his life, allowing him to develop into the rational being he has become. However, belief in the existence of a god can only ever be a matter of faith, -accepting as dogma what one has been told by priests, without question.

I am unable to give a scientific and balanced argument of pros and cons as to whether there is a god or not. But, as a reasonably well-educated member of the human species, I

believe that I am able to take a direct view of the question, "Does god exist?" and give an unequivocal answer.

In my case, the answer is "no".

Darwin arrived at his theory -*The Origin of Species* - in the middle of the nineteenth century, without the benefit of the knowledge that scientists have discovered since his time, including the nuclear reaction in the sun which produces heat and light, Einstein's theory of relativity, (the relationship between space and time), the Big Bang theory of the origin of matter, the age of the earth, fossils, DNA and genes. These facts have been found and favour his theory; none has so far been discovered to negate it. This seems convincing evidence to me – but clearly is not to people who refuse to read about such things. We must find simple ways to arouse their curiosity.

I believe that both the concepts of religion and the nation state have outlived their usefulness, so that they now pose an ever-present danger for our species. All three of the main Western religions remain antagonistic, one against the other, as they have always been. Even now, in the twenty-first century, members of one group are prepared to kill their fellow men who do not subscribe to their belief. Some even threaten those of different sects within their own religion.

Why are Christians, Jews and Muslims so irrevocably opposed? This book attempts to find an answer.

> *"How odd of God to choose the Jews*
> *But not as odd for those who choose*
> *A Jewish God, yet spurn the Jews"*

These lines were written by a member of the Oxford Movement, (one of whom was Cardinal Newman) in the Victorian era, when dons of the University were preoccupied by religious debate.

During the twentieth century, through which I lived for the majority of my life, many millions of people were killed due to the fact that their neighbour held a different religious belief from their own. They may both have believed in the same god or simply lived in a country with a different history, but they did not need much persuasion to kill each other. Nuclear weapons are now available to many countries. Ironic indeed if religion, having been one of the means for the survival of mankind, were now to become the trigger which brought about our demise. Religion divides and does not bring people together.

The nation state similarly has preferred, up to now, to exaggerate the differences between peoples and tried to create a feeling of being separate from one's neighbours – regrettably even that "we" are better than "they". That is certainly the message passed to their constituents by many politicians who believe in national sovereignty.

A better world for everyone on this tiny planet, perhaps even a new "Age of Enlightenment", can be brought about by man himself, with understanding and agreement from one to another. It can never be by divine intervention, as has been believed for the past five thousand years.

The word "atheist" is entirely negative. It says only what one is not. To be positive, I recommend that we should wish to be known as humanists – even perhaps cultural humanists and certainly realists – believing in the values and the

civilisations, especially the cities, produced by mankind in all places and throughout time.

Man's creativity has been overwhelming in the past in every field – philosophy, art, literature, architecture, politics, science, medicine, mechanical invention, social advancement and concern for one's fellowman. I do not believe that any of these spectacular advances came about by god's will but only by man's restless spirit of enquiry. There is no reason to suppose such creativity will suddenly cease to exist when religion and the nation state have come to a stop. Quite the contrary, all problems, whether caused by external forces or by man himself, can be overcome, as has been proved throughout our history.

There is a better world to come, but only if we can learn to work together, men and women of every nationality and social class, with no "creed" involved. This book has been written in an attempt to give a nudge to bring about that happy result as quickly as possible.

It seems to me that no one else has dared to make the connection between the evils men perpetrate upon themselves and religion. I fail to understand why not.

I grow old … I grow old …
I shall wear the bottoms of my trousers rolled
Shall I part my hair behind? Do I dare to eat a peach?
I shall wear white flannel trousers
And walk upon the beach.
I have heard the mermaids singing, each to each.
I do not think that they will sing to me.

T. S. Eliot, "The Love Song of J. Alfred Prufrock"

CONTENTS

Chapter 1

My Upbringing

1.1 England

I was fortunate in that neither of my parents was in the least religious – unusual in middle-class parents in 1930 London, where I was born. My mother taught me my numbers, to read and write and the difference between right and wrong, before I went to school at the age of six. I learnt from my father many things of great value. He had fought in the trenches of northern France during the First World War, joining up as a private and ending as a captain with a decoration for bravery. His was an unusual position because at that time prior to the Great War, officers were usually selected from the upper classes. Immediately after the war my father married my mother, the English-born daughter of a German immigrant.

One might have thought, having fought Germans for four years, every day of which his life was in the balance, he would not have married one. They married in 1919 in St. Clement's Dane church in the Strand, now the church of the RAF. He joined the RAF in the Second World War at the age of forty-seven.

1

My father never hated anyone, a good lesson indeed. He was a painter in the classical tradition. He met my mother at the St. Martin's School of Art just prior to the outbreak of the Great War. As a boy I was sometimes allowed to clean his brushes and never tired of watching him at work. He set up one of the first offices for advertising in London after "the war to end all wars" and his artistic ability was never in doubt.

I first became aware that there was a section of society, which was not as privileged as I, in 1936, when my elder brother took me down to the end of our lane, which joined into the Great North Road leading to Scotland. There we saw a troop of men, shabbily dressed and wearing cloth caps, marching down the road; they were led by one policeman, with another at the tail of the procession. There were no placards, no shouts, no message at all as to who they were nor why they were there. No religious or political leader as far as I could see was in charge or involved. My brother told me that they were the Hunger Marchers who had walked some three hundred miles from Jarrow, a town in the north-east of England. They were marching to complain to the Houses of Parliament and draw attention to their plight. They were unemployed workers from the shipbuilding industry with no money paid to them, as there was no dole in those days.

They and their families were hungry. At the age of six, I was surprised that there were people who were without food in my country. It made a great impression on me and I remember it well, even now in my late age.

I was brought up to respect my country, England (no one thought of themselves as "British", nor as belonging to the

"United Kingdom" at that time), but equally to know about people from other countries. My parents had friends in both Germany and the United States, whom I much enjoyed meeting when they visited us and remember speaking to them without reserve, a great part of my early education. As a small boy, my parents took me several times on holiday to Guernsey, where I first heard French spoken when I went to St. Peter Port harbour to talk to the sailors. I also remember that my mother and I packed parcels of tinned food and clothes to send as Christmas presents to Tristan da Cunah, "the world's loneliest island" in the middle of the Atlantic.

My parents were those sorts of people, even though they had not enjoyed the education that today we take for granted, nor had had the benefit of television. They were much concerned about the world into which they had been born and felt the need for it to be improved. They had both experienced great changes during their lives. Apart from the two world wars, through which they lived in great deprivation, the thirties were a period of depression and life was hardly normal as compared to the first decade of the1900s. Throughout their lives, difficult though they undoubtedly were, they remained entirely confident, relaxed and happy, - a marvellous atmosphere in which to bring up their children.

My father was very interested in modern technology. We had a telephone in our house. Unfortunately this was one of the first in our village so that I could not talk to my friends – and I, being unused to such a device, was terrified by it whenever it rang. We had a wireless set, also unusual at that time and I learnt a lot from listening to "Children's Hour" about the world and the history of my country.

Our house had three bedrooms and was detached, with a large garden and a garage, although we never had a car. Everyone walked a great deal more than today and all children walked or ran to school. There were few cars, although we were taught to be careful crossing any road. It was the time of the start of traffic lights, which were operated by the car passing over rubber contacts in the centre of the road. I discovered that, by jumping vigorously up and down on them, small boys could effect the same result. Birthdays and Christmas were a time of many presents for us children. I was always given books, which I much enjoyed, as well as toys. We lived a life of comparative luxury at a time of great hardship for many people.

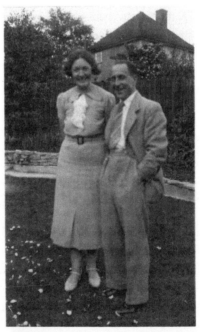

Photograph of my mother and father c.1937

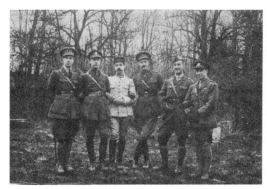

"Avec mon
meilleur souvenir au
2ⁿᵈ Lieut. T L Potter"

I Choquel
France 1918
Dad is on the extreme
right

Photograph of my father in France with friends 1918

On Sunday, 3 September 1939, I was playing in the garden when my mother called me in to listen to the wireless. The Prime Minister, Mr Chamberlain, announced the outbreak of war with Germany. I had only the vaguest idea of what it meant, although it was of great concern to my parents. They well remembered the huge number of men who were killed, on both sides, during those ghastly four years in the trenches of northern France. They did not wish such experiences to be repeated. My mother told me that once she had seen a German airship hovering above the Thames in London and delivering its load of bombs. As a result of the decimation of young men, many women were unable to get married and spent their lives alone doing good works, as an aunt of mine had done.

The bombing of cities was the great fear of everyone who knew of the devastation caused in the Spanish civil war three years before and the destruction of Guernica. Being a boy scout, I took part in civil defence exercises. I was told to play the part of being killed by a bomb. I should have much preferred to be wounded, as then I would have been taken to the local hospital, to which I had never been, but that was

not to be. I was merely given a cup of tea and sent home. We all had a national number (mine was BNAG 63/5) and a gas mask, which had to be carried at all times. Fortunately the gas masks were never needed. I still remember the pungent smell of the rubber and the difficulty of actually breathing with it in place.

A young boy was introduced into our class one morning. He was from Poland and could not speak a word of English. I was told to take him into the grounds of the school and teach him. All I could do was to point at the sky and say "sky", the trees and the earth. There were many such children who came to England for safety at that time. I wondered what it would be like to be taken away from one's country, to have to learn another language. I am curious to know what has become of him since.

One day, aged ten, at the beginning of the "Blitz", I came home from school to tell my mother that my teacher had told the class that children could apply to be taken to the countries of the Commonwealth to live during the war. Travel abroad was much less possible when I was young and few people had that opportunity. I asked my mother if she would put my name down for such a marvellous experience.

She did so and after some weeks said that I had been chosen to go. I was not allowed to tell anyone about it, not my closest friends nor any of my relations. My mother, having the greatest difficulty of telling any untruth, was in some distress when she had to tell our neighbour that I had gone to stay with my grandmother.

My parents took me to Euston station to board the train for Liverpool. There were hundreds of children on the platform

saying good-bye to their parents; many were weeping. I remember being very surprised at this. I was only extremely excited about the whole prospect of travelling across the world and regarded myself as being the most fortunate of boys. It was just the most marvellous adventure. I had enjoyed such a secure life at home, with loving parents – it never occurred to me that I might not be treated so well in another family, as some of the children were not. We spent four days in Liverpool, living in a huge warehouse with hundreds of beds stretching in all directions. On two consecutive nights we had to take to the shelters in the basement when the port was bombed.

I left Liverpool on the SS *Llanstephan Castle* bound for Cape Town. As was normal in time of war, we were in a large convoy of some thirty ships guarded by destroyers, which swept around at a fast rate – most exciting to watch. Several other ships also contained children going to America, Canada, Australia and other countries. Only a few days after we left port, I went on deck to see that we were entirely alone; not another ship was in sight. The captain told us that the ship bound for Canada had been torpedoed in the night and that many of the children had drowned. He had decided to use our ship's greater speed to leave the convoy and travel entirely alone. No other children were sent abroad after that.

The *Llanstephan Castle* was normally used to transport wealthy travellers to South Africa and the children were treated by the ship's crew as if we were equally important. All the luxuries were made available to us, including being called to the dining room by sailors walking round the deck banging a gong. It is still, in my opinion, the only way to travel. I much enjoyed seeing dolphins and flying fish

keeping us company and I spent my days reading books from the ship's library while perched on the rail.

"Crossing the Line", a ceremony which took place when we crossed the equator, was a memorable experience with the captain dressed as Father Neptune – small chance of that happening in an aeroplane these days. We were taught a little about the country where we were going to stay, including a song, "Sarie Marais", in Africaans, the Dutch language, which I still remember.

1.2 South Africa

It took four weeks to get to South Africa instead of the normal two, because we avoided all the usual shipping lanes and called in to Freetown in West Africa for supplies. This was the first occasion when I saw people who had a different skin colour from myself. We eventually arrived at Cape Town, where we stayed for some days. We went to the Prime Minister's house, Groote Schuur and met General Smuts, who gave us tea. I understood much later that he had fought as commander of the Boers, the Dutch force fighting for the independence of their settlers. When this was finally granted by the British government, he had been elected as Prime Minister and became great friends with Britain, a marvellous example to everyone. He joined Churchill to see the Normandy beaches soon after D-day. My father painted a portrait of Smuts, which he sent to my adopted parents on my return, in gratitude for the care they had shown to me.

Most of the children were selected to stay in Cape Town, but I, with perhaps twenty others, boarded a train for Durban, a town on the east coast. Three days later - (it was a slow train

and the distance was very far), on one Sunday morning, I arrived in Durban where I was met by my future adopted parents. It was most fortunate in that I was one of the first children who were on to the platform and was immediately chosen by them. That was how it was at that time; no lengthy period of selection processes to go through. I could not have chosen better.

The family, with whom I would stay for six years, had three children: two older daughters, Gwenyth and Joan and one son, Denys, who was much nearer my age. I was immediately made to feel at home and remember that, after supper, I joined them while they did their homework. I am afraid I must have been a great nuisance, as I asked many questions of them, but they did not complain. The next day I went to the local school and started on a voyage of discovery about my new country, even learning to play cricket, which I much enjoyed.

The whole family was extremely musical and the father sang regularly on the wireless. The first time I heard him sing "Figaro" from the *Barber of Seville,* the African servant was invited into the sitting room to hear him too. He, never having heard the wireless before, immediately recognised the voice and called him "Baas", the term all black Africans used, to speak to white people at that time. Subsequently, the boys in my school also nicknamed him "The Boss", which he certainly was. The mother played the cello while the two girls were experts on the piano (especially Chopin) and Denys preferred jazz.

Derek G Potter

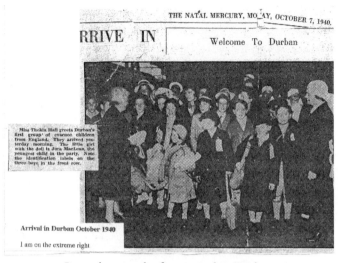

THE NATAL MERCURY, MO_AY, OCTOBER 7, 1940.

RRIVE IN | Welcome To Durban

Miss Thekla Hall greets Durban's first group of evacuee children from England. They arrived yesterday morning. The little girl with the doll is Jura MacLean, the youngest child in the party. Note the identification labels on the three boys in the front row.

Arrival in Durban October 1940

I am on the extreme right

Press photograph of my arrival in Durban

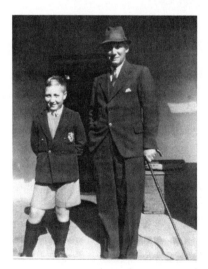

John Hudson and I
at Merchiston

Photograph of John Hudson and myself

Cecil Denys Derek Joan Gwenyth
[a cousin]

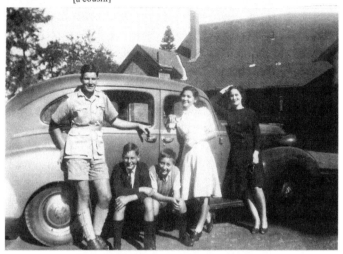

Photograph of my South African Family

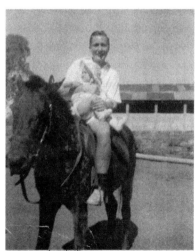

on horseback
with Gail
at Trewergie

Photograph of myself on horseback carrying
Gail, my newly arrived sister

The house where I lived was much the same size as I had known in England, but the location was quite different. I slept in an open room with Denys (there was a roof but no windows), overlooking Durban harbour. There we could see Sunderland flying boats coming in to "land" on the sea and all the ships arriving. Two native servants were employed for the house and garden, but my adopted mother did all the cooking and often took me to the Indian market to buy food. Once I had my photograph taken seated in a rickshaw with a Zulu, decked out in feathers, in the shafts. We were close to the beach and went swimming often, while knowing that sharks were often around too. I was once stung by a Portuguese man-of-war, a powerful jellyfish, so I soon realised that the Indian Ocean was rather different from the English Channel. It was also very much warmer.

The proprietor of the local shop which provided soft drinks and ice creams was Portuguese and we called him "Mr Certainly" because, whatever question was asked of him, that was the word he used. Whenever I took two wickets as the wicket-keeper or scored ten runs, I could run to the shop for a bottle of ginger beer. Durban is close to the Tropic of Capricorn, but I soon got used to the heat and followed Denys' habit of going barefoot, in spite of the pavements being hot enough to burn one's soles. It was not long before I was as tanned as Denys and I do not remember having any difficulty getting acclimatised.

Later I learnt that my country had not always behaved with tolerance towards other people. It came as a great surprise to me that the Dutch, who had been in the Cape Province of South Africa as long as the British, no longer wished to remain under their rule. The whole of their population, known as the Voortrekkers, had left Cape Town in the

1830s in hundreds of wagons, each drawn by a span of sixteen oxen. This evacuation was called The Great Trek and they travelled more than one thousand miles to settle in different parts of the country, in order to govern themselves. In the hills above Pietermaritzburg, the town to which the family had moved, I was shown the tracks of the wagon wheels, which had formed grooves in the stone by putting on their brakes, as they descended into the valley below. The town had been named after two of the Boer leaders, Piet Retief and Gert Maritz.

My adopted father, John Hudson, had been a choirboy in Durham Cathedral before he joined up in the First World War, going with his regiment, the Durham Light Infantry and had fought in German East Africa. He was a schoolmaster of considerable renown and was appointed headmaster of one of the best schools in Pietermaritzburg soon after I arrived.

This city was the capital of Natal and contained the State University as well as many boarding schools where parents in that vast country sent their children.

The schools were of various religious denominations – Anglican, Catholic, Methodist, Jewish and Dutch. It is difficult to imagine the differences from that which I had experienced in England. I even had to learn another language in my first school, Africaans, spoken by the Dutch. During the first lesson, not understanding a word of which was said, all I could do was to copy the writing of the girl sitting next to me. The teacher returned my submission with his inscription, "Do not copy the girl next to you, in future – she does not know any more than you do." One learns very fast under such circumstances.

I had far more freedom than in England, staying during school holidays on two farms, one in a remote part of Natal in a small village, where I could take a horse out on my own and ride wherever I wished throughout the countryside. The only habitations I saw were the Zulu kraals (mud huts with thatched roofs) dotted around the hillsides. I knew that the horse would find the quickest way home, so I had no fear of getting lost. One day I became aware of movement close by and soon saw a Zulu boy of about my age. He was very curious about this strange white boy. I saw him several times afterwards and we used to track each other through the bush. He was much better at doing so than I and would burst into laughter with a wide smile whenever he caught me. Neither of us could understand the other's language and we could communicate in no other way, but communicate we did, as one human being to another. His father made me a small version of the Zulu shield, clad in black and white cowhide and a knobkerrie, a weapon used for hitting enemies at close quarters, that was carved out of one piece of solid hardwood. It was then I understood that the boy had spoken to his father about me.

Our meals were much as I had had in England with the marvellous exception of, to me, completely new varieties of fruit: avocado pears, mangoes, granadillas (passion fruit), naartjies (tangerines) and many others, some of which I could pick from trees growing in the garden.

There were also different sports – rugby, tennis and swimming – all of which I much enjoyed. My school, Maritzburg College (where John Hudson was the headmaster), had been founded in 1868 with the motto "Pro Ares et Focis" – For Hearth and Home – and although a state school, it was run on similar lines to public schools in England. The colours

of the tie were a black background symbolising the Zulus, a thin white diagonal stripe for the British and a wider red stripe for the river of blood, commemorating the battle of Rorke's Drift.

This is superbly recorded in the film *Zulu*, which shows to perfection the Drakensberg hills and the Zulu maidens as I remember them. Thousands of Zulus fought there against a small band of British soldiers and many on both sides were killed. The British awarded eleven Victoria Crosses on that one day. The emblem on our tie was a Lee Enfield rifle and, balanced against it, the Zulu assagai, their deadly spear. We always felt that in some way, we were blood brothers with the Zulu nation. Our main hall had been used as a hospital during the Boer War; a sentry hut still stood outside the main entrance doors. Both the town and school were therefore very interconnected with the history of South Africa.

The school was and still is, very much into sporting activities. We played against all the other schools in both PMB and Durban and it was a rare occasion that we lost. I was not large or fast enough to play for the first fifteen, (rugby), but I did keep wicket for the first eleven, even with our fast bowler Cuan McCarthy, who later opened the bowling for both Cambridge and South Africa. Our captain was Jackie McGlew, who became the captain of South Africa. A recent captain of England, Kevin Peterson, was also at school at Maritzburg College, so the tradition continues.

Pietermaritzburg was close to Zululand and it was quite normal for the Zulus to walk an enormous distance to look for work in our town. The young girls were particularly striking to me as a boy; they walked erect, being used to

carry heavy water pots on their heads and were completely unaware of the effect they caused. Their "clothing" consisted only of a string of beads around their waist. No Zulu was permitted to walk on the pavement, so they were restricted to the dusty road in the gutter. The seats provided in the parks had signs in Africaans, painted on the back: *Blancs* and *Nie Blancs*: - whites and non-whites. The Zulus were only permitted to be served at one counter in the shops, which meant very long queues for them. Seating in buses was also segregated, as were trains. Some years before, Gandhi had been physically thrown off a train in Pietermaritzburg station because he had been sitting in the first class, although he was a barrister qualified in London and held a first class ticket. I understand that this has since become a place of pilgrimage as a result.

After taking my final matriculation examination, my South African parents kindly asked me to remain with them in order to go to university. I refused, but with great sadness, because they had treated me exactly as if I were their son. I wished very much to see my English family again. That was the reason I gave, but I had also become aware of the extreme differences between the races and how they were treated as "separate" by the laws passed to keep them apart.

It was not yet the full-scale "apartheid" system, which was to follow when the United party in government were defeated by the Nationalists (the Dutch), but it was extreme enough. It seemed to me that this was not how people should live in a civilised society and I felt that I could not continue my life there.

I was not to see my parents again, or my country, until January 1947, when I returned at the age of sixteen. I elected

to travel via East Africa because I wished to see the eastern side of the continent on my way home. I was seen off by my South African parents – a rather different parting from my first experience. It was necessary for me to be issued with a South African passport, as I had never had an English one. The ship, *Windsor Castle*, had been used as a troop ship and all passengers were allocated bunks used by the troops in several huge areas on the lower decks. Most of the passengers were soldiers returning from the east, with only a dozen civilians. There were also very few girls on board and they were monopolised by the soldiers, naturally enough, so I passed the time playing bridge with some older passengers and also acting as DJ for the occasional dances. We called in to several ports: Mombasa, Mogadishu, Aden and Alexandria.

Sailing through the Red Sea was quite superb; the stars were so large and luminous that one felt they could be plucked down by the handful. I went ashore whenever possible. I enjoyed the visits to Mombasa and Aden, but I had not enough money to go to Alexandria, being down to my last ten shillings; this I have always regretted.

We docked in Southampton, where I was met by my brother. None of the passengers was permitted to disembark before morning and no one from shore was allowed on board, but my brother; having been an officer in the Royal Navy, easily persuaded the sailor at the end of the gangplank to allow him to join me for the night. I was finally reunited with my father and mother at Waterloo Station and went to live in their small flat in St. John's Wood, just to the north of Regent's Park area in central London.

Thereafter my South African brother and sister visited my family in London on many occasions, although I never returned to the country where I had lived for so long. I am most pleased that, since those days, social conditions have changed completely. I am certain that, as a direct result of my personal experience, the more we live with people of other nationalities, especially the younger generation, the easier it will become to live together without discord. I am also delighted to know that Zulu boys are now able to attend my school, having won their places by scholarship.

Chapter 2

My Religious Experience

I had an idyllic childhood in England and never saw the interior of a church until I joined the scout movement, although I was taken by my aunt to visit Canterbury Cathedral and was quite overwhelmed by its grandeur.

I did read the Bible before I was twelve in South Africa and much enjoyed the beautiful use of period English, to say nothing of all the gory bits, learning more about sex and violence than from Winnie the Pooh. The James 1st version of the Old Testament contains so many extraordinary events and incredible characters that it should be required reading for everyone, even Muslims – not to be believed, but as an example of how people lived and thought at that time and as a valuable lesson to be sceptical of all religions. Even at the age of twelve, I believed neither of the sacred books and did not understand how anyone could.

> *It ain't necessarily so* *Porgy and Bess*
> *It ain't necessarily so* *Gershwin*
> *The things that you're lible*
> *To read in the Bible*
> *They ain't necessarily so*

My adopted parents, naturally enough believing that they had a responsibility for my religious education, placed me in a confirmation class in the Anglican cathedral in

Pietermaritzburg. There I was duly confirmed by the Bishop of Natal, Bishop Fisher; we choir boys called him "Fish our Bish". I discovered later that he was the brother of the then Archbishop of Canterbury Fisher, who crowned the Queen at her coronation.

At the age of fifteen, I was in the choir, where I much enjoyed singing all the old favourite hymns (often there were more boys in the choir than people in the congregation), when my voice broke. I decided, together with three friends, that since we had to go to church in any event, we would visit churches of other denominations as part of our education. I have to confess that I wished to discover which had the prettiest girls, - (mine was an all boys school). I remember that, in this department, the Methodists won hands down.

One Sunday we were sitting in the Roman Catholic Church, dressed in our instantly recognisable school uniforms. We had no difficulty in following the service because we had taken Latin (this was at the time when only Latin was used). The priest rose for his sermon and, to our great astonishment and extreme discomfort, he launched into a long diatribe against those parents who sent their children to non-Catholic schools. Because we were the only members of the congregation who were obviously attending a non-Catholic school, it was clear to everyone that it was directed against us - and our parents. It never occurred to him that we were there in a spirit of inquiry, to see what Roman Catholicism had to offer. He, as a Catholic priest, should have welcomed new converts, but that possibility never crossed his mind. I remember the occasion with great clarity and certainly learnt a lot that day.

It has been said that giving children something with which to go home and surprise their parents is one of the greatest gifts a teacher can have. I well remember my history teacher telling the class on his first day in the fifth form, "Historical facts are mostly well recorded, but I, as your teacher, am able to give you several different interpretations of those facts". What an inspiring teacher he was. Not too many, I suppose, would have opened his first lecture with such words. They have remained with me ever since, particularly in respect of religion.

We have all experienced manipulations on television, in the press and especially in political speeches, of "facts". Since that day, I have been sceptical of other people's interpretations. One must use one's intelligence to question and discover where the truth lies. Living in a democracy, we not only have the right, but also the responsibility, to question the conduct of the government we have elected and this is also true of the churches. Neither of those bodies should play the patriotic or religious cards and demand our allegiance without question.

My future wife was of a Methodist family and I have to say that I was much happier with them whenever we went with her parents to Chapel. I found it less pretentious and at least I knew all the hymns. One of her uncles was a Methodist minister and I naturally assumed that he would conduct our wedding service in the local chapel. However, Methodists believe that everyone should be seen to be equal and the congregation is grouped together in the centre of the chapel, with an aisle on two sides. This was not at all suitable for my wife-to-be. She had quite other ideas and was determined to walk down a central aisle, as she believed that this was the only proper way for a bride to be seen on her wedding day.

I would have married her over the blacksmith's anvil at Gretna Green if there had been a problem with her family, but everything was finally resolved and we got married in a fine old church in Finchley, which had originally been built as a Roman Catholic church. I do not know if some of the congregation felt uncomfortable as a consequence.

Her grandmother did not appear. She was a "Strict Baptist" and only had these words to say to me on the one occasion when I met her: "I don't mind the Jews, but I can't stand the Carthlics", looking at me very sharply. She obviously believed that Anglicans, who went to the Church of England, were not much different from those who attended the Roman Church. Such an attitude was not at all unusual and had been so since the Reformation.

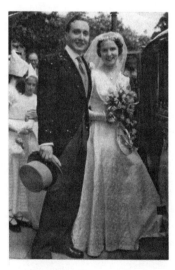

Passport to
Happiness
7th May 1955

Our Wedding Day 7 May 1955 Passport to Happiness

Chapter 3

Architecture

3.1 The Start

"Earth hath not anything to show more fair." – Wordsworth

The view from Westminster Bridge, when I first saw it after the war, was very different from that seen by Wordsworth. A large part of the buildings on the south bank of the river Thames had been destroyed and there were many gaps on the north bank too. It was then I decided that I wished to become involved in some way with the design and rebuilding of London, though I knew not how at that time. St. Paul's had miraculously escaped unscathed but the whole area for some two hundreds of yards around was covered in rubble. As students of architecture, our class went to sketch the building and we could see it from many more and different locations than are available today.

This was not the only change from my life in South Africa. The weather in 1947 was the worst in living memory and lasted until April. The roads were covered in thick ice and buses had the greatest difficulty in moving at all. Fortunately there were very few cars. Trains were also much delayed, especially those carrying coal from the mines, the only means of providing heat for most people. Rationing

of food and clothes remained for several years after the war and restaurants were forbidden by law to charge more than five shillings for a meal. However, we survived and I was delighted to be able to explore the great city of London. I spent much of my lunch hour in the British Museum close to my work; entry was free of charge and there were few people there.

I also frequented the cinema, enjoying the vast range of movies produced during that period. One cinema, in Oxford Street, showed only foreign films – French, Italian and Japanese – and often these were not even dubbed into English. Amongst the many memorable films I saw were, in no order of preference: *Citizen Kane, Les Enfants du Paradis, The Seven Samurai, Brief Encounter and La Dolce Vita.* The cinema was immensely popular, there being little television in those days. Often people went twice a week, but usually to British or American films. The present-day productions are not, in my view, up to the standard achieved in the fifties and sixties.

Soon after my return to England, I joined the London Polytechnic to study architecture, at first the night school, as I was employed as an office boy by an architectural firm during the day. One of my first jobs was to take site measurements of a kitchen in Mayfair. This was the Twenty- one Club, frequented by the young upper class, including Princess Margaret. I was shown into the kitchen and switched on the lights. The surfaces of the worktops, made of teak, were covered with thousands of cockroaches, which immediately scattered. No doubt many of the kitchens in central London were the same at that time. It was not surprising that they were to be replaced whether they had been bombed or not.

After a year, I applied for and most fortunately was awarded, a scholarship from the Royal Institute of British Architects and thereafter I was able to study full time. One of the first designs for a building, which we had to present, was for a fire station sited in the centre of a small town. It was the simplest of projects with only very few requirements: a garage for the fire engines with accommodation for firemen above. None of the students had had any experience of design before and I, along with everyone else, believed that all the solutions would be very similar. We had been subject to the same social conditions and had seen the same buildings throughout our lives. Above all, we were largely ignorant of the possibilities and different kinds of architectural styles then available. Every one of my fellow students was taken aback when our drawings were pinned up on the display wall. None were the same. From that day I realised that everyone has an individuality, which must be expressed; we are not sheep.

However much that social leaders, politicians and churches try to pretend that we are all the same and must conform to their dogma, they are doomed to failure. We have free will and are able to take our own decisions on the life we wish to lead. Freedom does not lead to dissent, social fragmentation or violent revolution, as long as we are able to express ourselves openly without coercion and can practise tolerance. As Jefferson is reported to have said, "Victory of toleration over fanaticism is inevitable."

Here I cite the example of the long fight against Apartheid in South Africa. The Dutch Reformed Church consistently maintained that the division of mankind was ordained by god and referred questioners to Deuteronomy. What the unreformed church was like, I hesitate to speculate. A few

courageous people, Father Trevor Huddleston amongst them, stood up for tolerance between the races and eventually the government was defeated. I remember hearing Huddleston speak in the Methodist Central Hall in Westminster during that period.

The first summer vacation I spent, together with three friends, in Corsica. I had contacted French students in Paris who were going down there and who had as little money to spend as we did. The secretary of this club said that we could join them as long as we agreed to sleep on the beach – possibly the start of Club Mediteranée? This was fine for us because none of us had travelled to France before and we wished, if possible, to visit two buildings designed by the Swiss architect Le Corbusier. We regarded him as the great architect for the future and this would be our only opportunity.

We were met at the Gare du Nord and were very surprised and pleased to realise that most of the French were young girl students from the Sorbonne. We joined the night train down south to Marseille and then the boat (sleeping on deck) to Ajaccio in Corsica. A happy time was spent by all. We sat around the campfire singing songs in the evenings, learning French ones and teaching them our English ones. Our meals were the simplest, mainly salad with a lot of tomatoes and we learnt to drink our coffee black, because there were no cows on the island at that time.

We did visit the Unité d'Habitation, designed by Le Corbusier near Marseille, a huge block of flats on piloti, containing an avenue of shops midway up the building. Construction was incomplete, but we saw a dramatic show apartment, which more than stimulated our imaginations.

On our return to Paris, we also visited his Swiss Students' Hostel, so our time was usefully employed. I have been a follower of Corbusier ever since.

Another architect of renown was Mies van der Rohe, who practised in Chicago and designed superb tall buildings along the lakeside. He had escaped from Germany, where he had made his name in the Bauhaus, a design studio in the same modernist style of the twenties. It was he who coined the phrases "Less is more" and "God is in the detail". Mies was awarded the Gold Medal for Architecture by the Royal Institute of British Architects in 1959. I and my student friends went to see the presentation and to listen to what the great man had to say. Unfortunately, he was overcome with emotion during the ceremony on the platform and had to be led away without saying a word.

I qualified from the Polytechnic in 1954, having had to take an extra year, as I contracted poliomyelitis midway through and spent time in hospital learning to walk again. Since then, I have had to wear a full-length calliper on my right leg and walk stiff-legged with a stick. This caused some consternation whenever I set foot on a new building site.

They are reputed to be one of the most dangerous of workplaces, but I am pleased to know that, perhaps as a result of my disability, no major accident occurred on any of my buildings. The men were more than usually conscious of what might happen to them if they did not take care. I spent most days in the hospital in the pool trying to teach the very young patients to swim. Some of them had never walked before and had to stand with heavy callipers on both legs. They would never know the exhilaration of standing beneath a ball, slowly revolving in the air high above, with

one's eyes fixed upon it, knowing one had to catch it - and hearing the pounding hooves of the opposing forwards coming relentlessly towards one.

The children's determination to succeed was most remarkable and gave me an understanding of how mankind reacts to and can overcome, immense physical difficulties. When my daughter was born ten years later, I managed to obtain the Salk vaccine from America for her – I could not allow her to go through what I had done, if at all possible. It was not until much later that the UK produced its own vaccine.

I was elected an Associate of the Royal Institute of British Architects in January 1957 and commenced a most enjoyable career. I first joined the London County Council, then in the building on the south of the Thames opposite the Houses of Parliament, but I only stayed for six months. I wished to gain site experience, but the local authority would not permit an inexperienced architect to go near a site.

3.2 Private Practice

I then joined a firm that was known as hospital architects. My final thesis had been to redesign the hospital I had been in: the Royal National Orthopaedic Hospital in Stanmore. This consisted of a collection of huts containing the wards, which had been erected during the war for wounded men and remains to this day much as it was when built. I was placed in charge of the refurbishment of St. George's Hospital, then at Hyde Park Corner. This was a classic hospital designed to follow the principles of Florence Nightingale after the Crimean War, with extremely high wards to allow the air to circulate and reduce the possibility of cross-infection.

I do not recall there was any case of MRSA as a result, no doubt also because, in those days, wards were entirely under the control of sisters and a matron. Not even surgeons were permitted to comment on how they should be run. Florence had left an indelible mark.

One ward was redeveloped at a time and, because I was constantly walking the hospital in every department, I was asked to wear a white coat so as not to raise concern amongst the patients. During my time there, I worked on several general wards, the maternity and the private patients' area. The operating theatre was still the same as when the building had been constructed, complete with an upper level of raked seating for the students to attend and watch the surgeon at work – hence the name "theatre", still in use today. The entire roof was of glass to ensure that the surgeon had sufficient light, gaslight not being powerful enough.

On one occasion I was asked to add a new basin in the theatre but had no instruction as to the size or location and in those days, no one was allowed to speak to, or ask questions of, the surgeon directly. I therefore got permission from the matron to watch an operation from the gallery to see where the basin should be placed. Having done so, I unilaterally chose the position and received no complaints afterwards. I remained in the hospital for three years and then decided to move on, in order to work on new designs for buildings rather than refurbish old ones. The hospital has recently been changed into a most expensive hotel, the Lanesborough, with the operating theatre now a magnificent dining room, which gives me much amusement.

I was fortunate to be selected by a firm known to be the most advanced modernist in England: Fry, Drew, Drake

and Lasdun. Max Fry and Jane Drew were well-known and had designed the best modern buildings in London before the war, representing the latest style of the thirties with no concession to the immediate past, that of the Edwardian era. They were, at the time, working with Le Corbusier, constructing the Indian centre for their new parliament in Chandigarh. I had no idea of who Lindsey Drake and Denys Lasdun were, (they were looking after the firm during Max and Jane's absence in India), but was soon to find out. As the most junior employee, I was given the job of designing new extensions for Marks and Spencer shops. To be truthful, little design was necessary because the standard look of their shops was identical one to another. However I was working entirely alone, which I much enjoyed, my only responsibility being to keep the client happy and earn the firm a constant cash flow.

One lunchtime, as I was alone in the office, the door opened and in walked a small man who was obviously one of the partners, although which one I was unaware. He questioned me about the drawing I was working on. I naturally stood up and called him "Sir" as one did in those days. As he left he turned and said, "Don't call me 'Sir', – I'm Denys." He remained Denys – and a good friend, ever afterwards. A year later he decided to leave Max and form his own practice. Everyone was invited to join him – except me. I was given no option.

He wanted me to continue working on Marks and Spencer's to produce a steady income for the new firm, which I was perfectly prepared to do. On one occasion, I managed to talk Denys into coming down to Brighton to attend a meeting with senior management of M and S, to make sure they understood that he was very much involved. He spent most

of the time sketching his design for the competition for Liverpool Catholic Cathedral.

Denys Lasdun had just won the competition for a new building for the Royal College of Physicians sited in Regents Park. This is, I believe, one of the greatest pieces of modern architecture in England in the twentieth century. It is quite extraordinary how he managed to persuade an antiquated society like RCP to accept such a modern design in the grandest area of Georgian London. His power of persuasion was another part of my education.

I learnt a lot during my time with Marks about running an office and how to deal with clients. M and S never kept records of anything to do with the development of their stores and I had to take along my files and consult them during the meetings. By this means they reduced their need to duplicate paperwork to the minimum and also ensured their architect was in complete control. As a result, I never allowed my secretary to do the filing so that I knew exactly where everything was. I was at Victoria Station one morning when a troop of men walked along the platform led by a small man. He marched along with the rest meekly following him. He turned suddenly and all the rest immediately about turned too. It was quite clear who was in charge. The leader was Michael Marks himself, with the entire board of directors. Three or four times a week he insisted that they paid an unexpected visit to inspect one of their stores, to ensure that his staff were performing properly.

The contracting firm of Bovis was always selected to act as construction manager, the first occasion I discovered this technique of construction and I learnt valuable lessons

from this close contact too. After completing several stores in the south of England, I decided that enough was enough and told Denys I wished to leave. He made me an offer I could not refuse – that of being responsible for the design and construction of three hundred student study bedrooms at Fitzwilliam College in Cambridge. The main building, comprising the central refectory, kitchens and Don's quarters had already been completed. Again, I was left almost entirely on my own, with only a junior partner to keep an eye on me. Working on the design of a truly modern building gave me much pleasure.

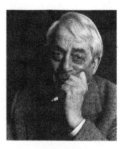

Denys Lasdun
1914 - 2001

A Memorial Celebration
Royal College of Physicians
Sunday, October 21st, 2001

Photograph of Sir Denys Lasdun OM

"You cannot have form, in architecture, which is unrelated to human needs; and you cannot serve human needs in terms of architecture, without a sense of form or space. Architecture, for me, at any rate, only makes sense as the promoter and extender of human relations, but has to communicate through the language of form and space, if it is said to be considered, an art. And it is unequivocally an art."

Denys said these words during the presentation of the Gold Medal to him by the RIBA in 1977.

This was the start of a huge number of new university buildings built throughout the country and I worked on three of them, in particular Christ's College, Cambridge. The Master's Lodge was a Jacobean building, early seventeenth century, which had been altered by the Victorians, who had added a top floor of ten small rooms for the servants. Apart from this, not much had changed and the new master's wife, Lady Todd, refused to occupy it until it had been brought up to date. I worked closely with her and succeeded in opening the house up, making it much more liveable and yet retain the character of the original period. During the demolition of some walls, a large piece of wallpaper was revealed. Because it was obviously very old, I phoned the British Museum to see if they were interested. An historian arrived the next day, very excited. It subsequently transpired to be the oldest wallpaper yet found, had been printed on the reverse side of a Papal Bull, (instructions from the Pope) and was of the pre-Reformation period. Paper was very rare at that time and, not wishing to throw it away, someone had reused it – one of the first examples of recycling?

The services engineer on the project lived in a village nearby and told me that his local Council had made an offer of free building sites locally, as long as the owner would construct a house for his own occupation. In my spare time at home, I designed a small house for him to build with a friend of his and applied for planning permission, which was duly granted. They built it very well; I used to go on inspection from time to time. I did not charge any fee but most enjoyed seeing my design take shape.

In 1963 Denys was appointed to design the National Theatre on the south bank of the Thames. In order to reduce the construction period to the minimum, it was decided to split the contract into two parts – one from the car park basement up to the ground floor and the second, - the main theatrical stages, dressing rooms and offices above. This arrangement allowed an extra year for their detailed design. I was entrusted with the first contract so, although I was not directly involved with the entire design, I can claim to have contributed to this extraordinary building. I also met Lawrence Olivier quite unexpectedly. He was chewing an apple when he came one day to see the model I was working on and only Denys spoke.

3.3 My Contribution

During this period, I had been contacted by an old people's home, two streets away from my home in Finchley. They were short of money, as all charities are and I was asked for my advice as to what could be done with their property. The garden was extremely long and ended on another road and pavement, so I recommended that they should apply for planning permission for two houses and sell half of their garden, which should produce a large financial gain. This they duly did; again I designed the scheme for planning application without charging any fees – I was of course in full employment anyway.

The old people's home was owned by an Anglican group of nuns, the Community of St. Andrew, based in Notting Hill Gate. The Mother Superior was so pleased with my efforts, no doubt also appreciating that I had made no charge, that

she invited me to become a trustee of the charity. There was only one other trustee, the solicitor, so he, Mother Joanna and I ran the entire organisation from their financial point of view, holding meetings once a month. This gave me an insight into two entirely different worlds: that of a religious organisation and of financial control. They both proved extremely illuminating.

Only a year later, the Rev. Mother Joanna received a letter from Westminster Council issuing a compulsory purchase order on the main buildings, including a fine Victorian chapel, which the convent had occupied for over one hundred years. The Council wished to redevelop the entire area, which, apart from the convent, had fallen into disrepair, with poor drainage and leaking roofs. It had become virtual slum property and the Council would not put up with the situation any longer. We arranged to go to see the mayor and planning officer to try to reverse their decision. One of my arguments was to suggest that the nuns would provide a socially cohesive stability for the new residents, being instantly recognisable in their dress and demeanour walking about the streets. Final agreement was reached that the main house and chapel would be allowed to remain, provided that a new building should replace four small houses where most of the nuns lived.

I prepared a scheme, which received planning permission. This proposed that two of the convent's house sites would be exchanged for two owned by the Council on the adjoining street and the whole area occupied by the nuns could then be enclosed by the new building, which would now be able to span between the two streets. It would also allow a private internal garden to be provided for the community below street level. However, well knowing the poor financial

position of the charity, I doubted very much that it would ever be built.

I should not have worried. I had not realised the influence that the order had and the Bishop of London ensured that the city provided the necessary funds almost immediately.

At the time of my original design, I had no idea of how a nunnery should function. I therefore asked the Mother Superior to allow me to spend two days and nights in the community, following them around to see how they operated. It proved to be most fortunate that I did so, as I discovered that, rising at 4:00 a.m., the nuns formally processed two by two to chapel. They were then clad in the voluminous gowns of traditional nun's attire and, due to some of them being rather statuesque, the corridors and staircases needed to be much wider than normal. The windows of the bedrooms on the two top floors were also deeply recessed to provide complete privacy, with full height glazing for the lower teaching rooms, refectory and library.

I then told Denys that I wished to form my own practice, which I duly did. I left the firm but retained my close friendship with Denys. The convent was successfully completed in 1974 and opened by the Queen Mother, who was well-known to the order. Unfortunately, that was the start of another recession. The government decreed that no one was supposed to work more than three days a week and new contracts were few and far between for a fledgling practice. My partner and I spent some of our spare time learning to fly a glider, our office being in Dunstable close to the London Flying Club.

I had kept in touch with my friends and on one occasion, I went to talk to Denys and told him of my difficult situation.

He said he was designing a new building for the European Investment Bank in Luxembourg and, after some time, I asked him if I could go and act as the architect on site. He agreed and so I closed my office and moved to Europe.

Photograph of the Convent in Tavistock Road, Notting Hill Gate

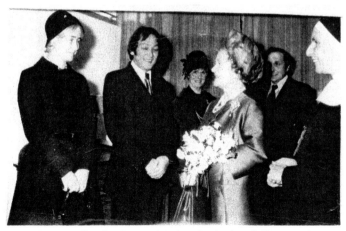

Opening by the Queen Mother St. Andrew's Day 1974

My wife and daughter were both enthusiastic about the prospect, even though we had little idea what living in Luxembourg would be like. We had appreciated many holidays in France, Switzerland and Italy, we believed it would be most enjoyable - and so it proved. My family have never had the slightest apprehension about such a move.

Some years before we left, my wife had been asked to act as secretary for the local Conservative party in Finchley and we had both met Margaret Thatcher, who was our Member of Parliament. She once came to celebrate her birthday with the borough officials in our house. I spent most of the evening talking to Dennis, her husband, in the kitchen with a quiet drink, neither of us being interested in local politics. I therefore felt no apprehension in writing to Margaret from Luxembourg, when it became quite clear that she would become the next Prime Minister. In addition to the obvious problem for her government to repair the country's finances, I urged her to deal with the intractable question of Northern Ireland. She had not held any of the major offices of state, was untainted by the past and was also the first woman to become Prime Minister. She was in a unique position to be able to take radical action.

I recommended that the Northern Irish people should be told that the UK would leave their country in five years and that they had to arrange to govern themselves within that period. I did receive a letter from her, but it made clear that she could not bring herself to consider such a course of action at that time. In effect, that is what Tony Blair did, twenty- five years later.

How much suffering would have been avoided had she been able to do it then?

3.4 IBM London

The European Bank was successfully completed in four years, rather longer than the original programme. It finally opened in 1980 and we returned to England. Denys Lasdun then gave me a similar responsibility, of looking after the construction of a new building for International Business Machines, the American company manufacturing computers. The site was immediately next to the National Theatre on the south bank of the Thames and opposite St. Paul's. It was the first time that I got to know Americans, whom I found very refreshing. I learnt from them that the name of the company should really stand for "I've Been Moved" – the policy being that no one should stay in the same job, even the same country, for very long. In this way, everyone in the company was constantly kept on their toes.

As a result of this, I have since then, come to the conclusion that the only truly democratic decision that we, the electorate, should give at the time of an election, is to vote for the opposition. The choices offered between all of the political parties are rarely sufficiently different, one from the other, as to be able to choose between them and a change of government is more likely to bring improvements than not.

Press

FRIERN BARNET CHRO[N]
and MUSWELL HILL P

FRIDAY, OCTOBER 19, 1973

P[

Happy birthday, Minister

EDUCATION Minister Mrs. Margaret Thatcher didn't even have time to change for her birthday party in her hurry back from the Conservative Party Conference in Blackpool. But her guests for the event at 148, Hendon Lane, Church End Finchley, on Saturday claimed she looked "just right" in her blue outfit.

Instead of a cake she received a bowl of white heather—for "good luck"—surrounded by African violets. It was presented by Sarah Potter, the daughter of Mrs. D. Potter, who, as secretary for St. Mary's Conservatives, was host for the evening.

The branch's chairman, Mrs. Colline Maciyn, arranged for a special card by an Australian artist, Arthur Gibson, now living locally. This was presented by her daughter, Wendy, and was a satirical look at Mrs. Thatcher's own education. It was signed by all the 85 guests at the cocktail party.

The branch chairman, Mr. Frank Richns, introduced Mrs. Thatcher to them, as MP for Finchley and Friern Barnet. They were thanked by Mrs. Thatcher sincerely for coming to make her 48th birthday so enjoyable.

Although she had hardly had time to think in the dash from Blackpool, she gave a 20-minute speech, mainly on the conference.

The guests at the party included the Deputy Mayor and chairman of Finchley and Friern Barnet Conservatives, Cr. Jimmy Sigsted, Cr. Leslie Sussman and Cr. Miles Golding. Finchley ward's third councillor, Mrs. Betty Gibson, was unable to attend owing to a previous engagement in her capacity as mayoress.

Mrs. Thatcher joined in the fun — and food, arranged by a committee of ladies from the branch — until she reluctantly had to go at 28.20 p.m.

Press cutting of Margaret Thatcher and my daughter.

Nearing the end of the structural construction, I was phoned from the office to ask me to show the American Chairman of IBM around the site, there being no partner available. This seemed somewhat strange because there was very little for him to see. All the concrete floors, columns, staircases and roof were completed, but nothing else. The external cladding (glazing), internal partitions and doors had yet to be started. There was nothing to show how it would be

subdivided. His staff in London would surely have known the state of the building and had all the drawings for him to see how the offices would be organised. However I, together with one of the senior members of the contractors, met the delegation when they arrived.

The chairman of this major U.S. company had only one question to put to me after introductions. "Please show me where my office is to be." This had been located on the main entrance floor, with an internal planted area and the boardroom immediately adjacent. Without doubt, the location had been agreed with the UK directors, after much discussion with the architects and engineers. The positioning of all other departments would have also hinged on this decision. I arranged for the demarcation of the office and boardroom to be indicated on the concrete floor in chalk. Having seen this he turned to me and asked, "Tell me, Mr Potter, if you were me, where would you put your office?"

I knew perfectly well what the politically correct response should have been: where the design said it should be, as it had been decided with all parties in agreement. It would badly affect the construction programme to consider making any such radical change at this late stage. I did not do so, but took him at his word. I felt that I was old enough and had had enough experience to be able to do that. I led everyone up the staircases to the top floor overlooking the river and St. Paul's, with the Houses of Parliament in the distance.

I said, "I am a Londoner and would want visitors to be able to see my town from my office." After a brief discussion with his board, he turned and said, "My office will be changed as you suggest" and then left. On reflexion, it seemed to me that he had seen the plans and had not liked what he

saw. That was the only reason for his visit and I had done the right thing. Americans are able to make their minds up quickly and without a long debate. I was fortunate in that later, I lived in a flat in Canary Wharf which overlooked the river and could enjoy a similar view from the balcony: St. Paul's, Somerset House, Waterloo Bridge and Big Ben.

The IBM building was designed to house the latest examples of computers to demonstrate their ability to potential customers. At that time in 1980 they were colossal machines whirring away in the basement, but they had only the capacity of the smallest laptop of today. Technological change happens fast these days.

I had been expecting, for my next assignment, to go out to Baghdad for Arup Associates, who were designing a large residential and shopping complex in the centre on the banks of the river Tigris. I always have liked the rivers of a city. Sitting in my site hut one day, the door opened and in walked a stunning young lady Iraqi engineer who had obviously been sent over to check me out. We went around the building and talked about the new project. Unfortunately, Saddam Hussein decided to invade Iran and the project was cancelled almost immediately, much to my chagrin. I was much looking forward to visiting Babylon, to say nothing of working with the lady engineer.

Instead I was sent out to Saudi Arabia.

Aerial photograph of the National Theatre and IBM

3.5 Design through the Ages

During the eighteenth century, it was held that good architecture, could only be produced by a subtle blending of three elements:

- **Commodity** – the successful solving of the requirements for the building's use
- **Firmnesse** – visual solidity, together with structural strength
- **Delight** – pleasure -which should contain, to some degree, an element of surprise

During our stay in Luxembourg, I went to a lecture on a new architectural theory called post-modernism, which was

given by a lecturer from one of the schools in London. He showed slides of a series of buildings in Florida, which he claimed were the future development of modern architecture. I, having been a modernist in the classical tradition, found these examples trite and unsatisfactory, being made up with different colours and whimsical shapes of no character – in a word, paper-architecture without substance. My wife, who was with me, was most surprised when I stood up at the end of the lecture, quoting the principles of good architecture and made it clear that I did not agree, - that this new theory could lead nowhere. I was the only person to speak and the lecture came to an abrupt end. But so it proved.

There are two examples of post-modernist design in London which seem to me to exemplify the backwater to which this theory inevitably led: No. 1 Poultry, opposite the Bank of England in the heart of the city, by James Stirling and MI 6 on Vauxhall Bridge. I find them extraordinarily vulgar and out of character with their surroundings. I am sure that Denys would have been of the same opinion. He always tried to find, in a visual context, what he termed "the grain of the city" before starting to consider the design of a building.

As an architect, I must solve my client's problem by designing a building for his unique use and which will not only be well built, but also give delight to all who see and work in it. However, I am always aware that there are many other possibilities. I have to believe that I have found the right solution for my client, whilst knowing perfectly well that, not only do I have a choice of several alternatives, but also that another architect could produce a different and equally successful building. Architects have never been able to enjoy the luxury of "proof" before taking their decisions.

At the same time, if I am not completely happy with my design, I will fail to convince my client and arguments will be endless. Chaos will prevail. A building designed by a committee is doomed to failure. Architects have been given the name of being arrogant in this respect and we must plead guilty to that charge. But equally, we must always maintain our principles.

On my return from Saudi Arabia, I was given, by the architectural firm Arup Associates, the responsibility of working on a scheme for a new high-tech. business park, just to the north of Heathrow, called Stockley Park.

The site was a 400-acre rubbish dump, devoid of plant life, - not even weeds would grow there. It was included in the "Green Belt", an area around London where no buildings could be built. Municipal garbage from west London had been ferried down the canal and placed in huge excavated sand pits, some twelve metres deep, during the previous century. As a result, it was contaminated with toxic gases including methane (explosive) and heavy metals. The Council could find no use for it and this huge area devalued all the housing nearby. Only the local boys rode their motorcycles over it.

The solution, which the architects found, together with an enlightened client, was radical. All the old garbage had to be removed from a third of the area and placed in new excavations. Sand from those was transported back to build up the levels to what they had been before. Excavations continued day and night. At that time, Stockley Park was the largest construction site in Europe.

The transformed area was where the new buildings were to be located. We also formed several lakes with grassy banks

and planted hundreds of semi-mature trees – again, one of the first times that this technique had been attempted. This was to ensure that suitable, high-profile tenants would be found as soon as possible. Car parks for each building were enclosed behind high hedgerows, again to ensure the immediate effect of an open parkland, rather than a city office complex. It did become a pleasant place to work. The offices were only three stories high, white exteriors with dark grey slate roofs and did not detract from the greenery surrounding them. The staff could relax and appreciate living and working in a completely different environment from that to which they had been used. The areas where the rubbish had been relocated were landscaped and used as an eighteen-hole golf course, which was much appreciated by the Japanese companies, who occupied some of the buildings.

The whole scheme took many years to complete, but proved immensely successful and won an embarrassing number of awards. There are always many improvements which can be made to even the worst environment and which are economically viable, given good design and the confidence of those involved.

During this process, I went to supervise the construction of an hotel in Newcastle-upon-Tyne, the Copthorne Hotel, on the banks of the river. My wife and I moved there for two years and much enjoyed the experience, making new friends and seeing a part of England and Scotland neither of us had been to before. It is indeed very different from the south and the "Geordies "are quite distinct too. My wife and I found them very open and they did not appear to show any objection to Londoners. At that time, the whole city was in the process of being renovated, but the film *Get Carter*, with

a young Michael Caine, shows what a hard life the people had to endure in the sixties in Newcastle.

3.7 Retirement

The hotel was a success but, shortly after I had retired, the firm, Arup, asked me back as a freelancer, to organise their defence in the High Court. The client, whom I well knew, had started a civil case against Arup, alleging that he had not been kept sufficiently informed of the final cost of construction of the hotel. He was claiming damages against Arup of six million pounds. Because I had been closely involved, the firm asked me to organise their defence through their lawyers, as they did not want to take any of their staff away from other contracts. It was explained that it should not last longer than three months, as Arup always settled out of court. I was responsible for going through the three hundred boxed files, making accurate lists of their contents and ensuring that our legal team knew everything about the contract. In the event the case did go to court and lasted three years, Arup's offer of half the amount to settle having been rejected by the opposition. My task was relatively easy because I had seen all the documents during the work, had written many of the letters and all of the progress reports.

This was my first encounter with the law and I found it fascinating. Our defence, in addition to the solicitor, had two barristers who were my particular contacts, with a senior Queen's Counsel in overall charge. During the actual trial, which lasted four months, there were six attorneys (all wearing wigs) in court, so it was proving to be a most

expensive case. I was one of the first witnesses for the defence to be called. In my initial statement, I had implied that the client was insufficiently experienced; he had refused to take my advice and accepted the contractor's opinion on one important matter. In cross-examination, the opposing barrister, a lady, suggested that I had criticised the client for being too old. "Certainly not," I replied. "I am older than he is. It is a matter of lack of experience." That concluded my examination. I was only in the witness box for ten minutes, much to my annoyance, as I was rather enjoying the experience. The outcome proved entirely successful for Arup, who were awarded full costs, including my fee.

3.7 Battersea Power Station

In a letter printed in the *Times* in May 2000, I proposed that Battersea Power Station be demolished and the site used for low-cost housing, so desperately needed for those valuable people who must live in London, but are unable to afford it. Several thousand teachers, nurses, police, firemen and their families could be accommodated in the heart of the city. A riverboat service would connect all the main centres – Chelsea, Whitehall, the city, the south bank, Canary Wharf and Greenwich – thus reducing to a minimum the need for yet more cars in central London. Had my suggestion been carried out in 2000, the Borough of Wandsworth would have benefitted financially from the resulting council taxes instead of having a huge white elephant on its hands, which can never serve any useful purpose. It remains completely sterile.

Battersea power station was opened in 1942 and closed down in 1968 after coal-fired furnaces were banned in London. It has become derelict during the forty years since then. The roof was taken off and the interior has been subjected to all the extremes of weather, resulting in the probable structural failure of the three-hundred feet high flues.

Many planning applications have been made for the development of this important site, but are always rejected by the Council, who wish to retain their iconic structure. The Borough has almost no other building in which they can take pride, so it is natural for them to act in this way. However, it is impossible, in my opinion, to design any building of quality close to the station, the scale of which would completely dominate and overshadow any other. A splendidly designed project, without the station, could be of much greater significance and bring a renewal of life to Wandsworth than the dismal structure, which now exists.

We do have a great historic heritage in Britain, which should be celebrated, but that must not be allowed to prevent sensible decisions from being taken, - decisions which will bring an improvement to the lives and benefit all the citizens of this great city.

Brian, a great friend, produced this, following my letter in the *Times*.

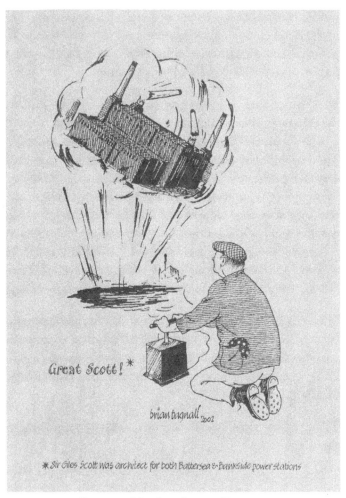

Cartoon of the demolition of Battersea
Power Station by Brian Bagnall

3.8 The Anglican Communion

In 2002, I was asked by the Anglican Communion (the Church of England worldwide) to redesign the convent, as there were then only four nuns in occupation.

The others had retired, the order was in terminal decline and the cost of maintenance was too high for such a small number. The Anglican Communion wished to relocate their offices from Waterloo and was persuaded by Archbishop Carey that the building in Notting Hill would be eminently suitable after renovation. It would not only provide the office accommodation they needed, but also the top two floors could be used as bedrooms for clergy visiting from abroad, thus eliminating the cost of having to provide hotels.

In my planning application to Westminster Council, I proposed that, on the roof, there would be solar panels to provide some electrical power and a roof garden. I also wished to enlarge the windows, which had been designed for privacy and would not provide sufficient daylight for offices. The planning department refused to contemplate any external change to the building, whether roof garden, solar panels or windows, even though I had been the original architect. My client was most desirous of completing the internal alterations as soon as possible so that they could occupy the premises. There was a considerable sum of money at stake and I therefore agreed not to make an appeal against the rejection, which would have taken two years at least.

I decided to cut a large hole in the roof and the floor below, with a glazed roof light covering the opening, to admit light into the centre of the building on those two floors where the offices were to be located. This proved a successful solution

and allowed open plan rooms for different departments to work together. Offices were enclosed by full-height glass partitions, ensuring that the incoming daylight from above would penetrate the whole area equally and be unobstructed. The planning officers of Westminster Council could not foresee that solar panels or a roof garden were desirable to be achieved in their own right. I am sure that nowadays, both would be required before planning permission was granted.

The alterations were completed and the building reopened by the Archbishop of Canterbury, Rowan Williams, in 2004. This was the period when the Anglican Communion was at the point of splitting over the appointment of homosexual bishops. The *Times* commented, following the opening ceremony, that it was a case of the deckchairs being rearranged on the Titanic.

The Archbishop opened the building by staying in each area and blessing it. He came with three different robes, all of heavy silk and embroidered. They signified obvious wealth, but they could hardly have been meant to impress his god. There was only one reason for them, - to impress his flock and even perhaps to show that the Church of England was of an equal stature to that of the Church of Rome.

I stayed on after completion, giving advice to the client on how to run the building, as they had never had that responsibility before. It is always a great pleasure to see how people use the spaces one has created, sometimes in quite different ways from those which one had imagined.

The officers of the organisation were enjoying being in a completely different environment from that to which they had been used. Notting Hill Gate is a more relaxed area

of London than Waterloo and they now had a private garden with a grass lawn, together with their own kitchen and restaurant. The ten bedrooms were transformed with private shower and toilet facilities and put to good use, - (it is most unusual for an office building to contain such accommodation, - the two types normally require quite distinct regulations). The splendid Victorian chapel built for the community was also much appreciated. I arranged for an outline drawing of a nun to be engraved on the glass entrance doors to remind everyone who entered, for whom the building had originally been designed.

When a building can be reused in a sensitive way, which prolongs its useful life, there should be no difficulty in so doing. I am surprised to learn that few other architects have had the privilege of reworking their own building and I was grateful to be given that opportunity.

Chapter 4

Human Development

4.1 Evolution

Having spoken about my particular experiences in life, I shall return to the start of human endeavour.

It is at least five million years since mankind left his animal cousins on his solitary journey. His nearest relative, the chimpanzee, is remarkably similar in almost every respect, but man is so different in the one achievement: the ability to plan ahead.

"One giant leap for mankind" did not happen in 1969 when Neil Armstrong stepped on to the surface of the moon. As Dr. Jacob Bronowski recorded in *The Ascent of Man*, it occurred four hundred thousand years ago, when Peking man discovered the ability to control fire. This knowledge spread quickly throughout the world. It is remarkable that, during the history of mankind, similar innovations have occurred in different parts of the world at almost the same time. Religion and social advancements are both cases in point, which will be dealt with later. When mankind first discovered the means of producing fire, a most valuable extension to his way of life was added.

Skulls of the first men we have discovered, Homo erectus from one million years ago, were living in East Africa, a warm environment. Fire was unnecessary for their survival and development. Over many years, mankind migrated across vast areas of country, always travelling north for reasons not yet established, with two major waves: one ending up in China, the other in Europe. This occurred shortly before the earth's temperature changed dramatically, bringing on the first ice age. Such a catastrophic change in the environment was, of course, nothing to do with mankind. It was an impersonal event, due probably to the sun's reduction in light and heat, or a change in the earth's axis. At almost exactly the same time, man discovered how to control fire.

Without this achievement, man as a species would almost certainly have become extinct, as others have done, including such long-lived species as the dinosaurs. Every species has evolved in that precise way, over many millions of years, to change their situation in order for them to survive, as Darwin clearly demonstrated, whether in the animal or vegetable kingdoms.

Fire was essential to man's existence at that precise moment. It was inevitable that he discovered it. That set him apart from other mammals and, in the course of time, on to the creative paths he has followed ever since.

Fire changed the necessity for men to sleep when the sun went down. They could now protect themselves against wild beasts, cook their meals and, above all, gather around the fire to relax, a quiet time for the tribe to start to form a community – eating a meal, learning to talk together, even singing and chanting together. That is the reason why almost everyone throughout the world enjoys the

experience of sitting around a campfire and the conviviality and comradeship which it engenders. It is now claimed that the very fact of cooking meat resulted in an advance in the brain's development.

Four hundred thousand years is too difficult to comprehend for one who has only a short period of time on this planet and it is sensible to translate it into "generations". Taking an average of five generations per century, as was likely in the early days, there would then have been approximately twenty thousand generations of mothers and fathers talking to their sons and daughters since that time, whilst seated around the fire every evening. The development of language also greatly benefited from such a convivial gathering. At this time, they could pass on their experiences to their children, especially the sons, as valuable lessons in self-preservation. The son was much the most likely to be exposed to danger.

Since the discovery of fire, mankind was dependent upon the survival of small, mobile groups. There is safety in numbers. Life was precarious and it was more important for the group to continue than individuals. In particular, the children would have been taught which foods it was safe to eat and the places to which they should never go. These taboos have been transmitted down to us with the knowledge of their reasoning long since lost and many have since become meaningless religious shibboleths. The prohibition of eating pork, different methods of killing animals and the holiness of places immediately spring to mind.

For several hundred thousand years, men lived their lives with hardly any difference from animals. Over the course of time, they learnt how to make and use tools – quite different from those they needed for the hunt. Many of

those groups must have perished, but enough adapted to the place where they lived and to their changing conditions. They won through for the continuation of the species.

Darwin came to that conclusion about every species which he investigated and, to my mind, this is incontrovertible. Man is no exception.

One other giant step occurred on the way towards civilisation, when man stopped the annual trek to follow the herds of migrating animals. He discovered that he could stay in one place and only then begin to dominate his environment. Civilisation could never have developed on the move. This occurred in the Nile Valley about ten thousand years ago, or five hundred generations.

He learned that if he scattered seeds of wheat upon the fertile ground, they would germinate and produce food for him to gather in some months' time. In order to harvest the crop, he invented a sickle. The shape of this was so perfect that it has hardly changed – only the material, from stone to metal. Then came the plough and that extraordinary leap forward, the wheel. No one was likely to invent such an object unless there was so great a need that it became an essential tool for survival. Man has always responded to a specific necessity and able to use his mind to resolve a problem. Animals became domesticated – goats, sheep, cattle and especially dogs, who were regarded early on as man's best friend. Again, this could only be achieved if men were settled in one place.

Such advancements allowed mankind freedom from the drudgery of having to concentrate solely on the means for survival and always being on the move. Above all, man showed that he was a creature who could plan for the future,

which made him distinct, at last, from the animal world. The freedom gained proved to be crucial for the future destiny of man. It allowed him time to think – and to wonder. Man, being one of the few creatures able to raise his head and look upwards, did so and saw the stars in the sky above him. He noticed that the arrangement of the moon and the stars changed from night to night and, being of an enquiring mind, he wondered why. Man is, above all, a questioning animal. He attempts to provide answers to such questions, using the knowledge, which he has built up through his experience.

It is fundamental for the future advancement of the world, as it was in the past, for us to question everything to the limit of our present-day knowledge. There can never be answers without questions. Religions, however, do not agree.

The male in the family was the person who went out of the home daily and returned with the meat necessary for life. Fathers have always been regarded as being important and very different from mothers. Mothers were always there from birth; they were an ever-present source of love and understanding and could comfort one in time of trouble. As fathers were usually absent, they were the persons who issued chastisement on their return if they disapproved of their children's actions, as is normal even today.

Fathers were also responsible for their education in the ways of the world they knew. During such teachings they would undoubtedly have referred to those experiences which they had had personally, but also those about which their father had told them. In a world where speech was the only means of communication, transmission of information and

warnings for self-preservation could only be by word of mouth.

All generations largely follow tradition and it is unsurprising that these tales have been perpetuated down the centuries. Until much later, when writing was invented, they relied entirely upon the memory of those speaking. No wonder that the messages were vastly altered during this lengthy period. Men have enjoyed the telling of tales ever since and, as always when men told their stories, they became more and more elaborated. We shall experience some of these extraordinary tales later.

For another five thousand years, men existed in small settlements, again largely independent and, until the advent of the horse, almost without contact with any other tribes, until the arrival of something we call society.

4.2 Magic and Ancestor Worship

Man knew that he had not formed the earth upon which he lived, - he only controlled small parts of it. He could make plants grow and keep animals for his food. He had some authority over his domain, but he also knew he had had no part in creating the wider world, over which he had little or no control. Originally he must have thought that this had been produced by magic, a natural conclusion. This solved the problem – anything he could not explain, which was the entire natural world in which he lived, had been magically produced.

Very early on, man pretended to use magic, both to improve his success in catching the animals he needed to survive and

also for fertility to produce the next generation. There are many examples of cave paintings of animals, so precisely drawn that they are instantly recognisable. They could only have been produced with great difficulty and with the use of wooden torches, being buried deep within the caves of southern France and other places. These are regarded by everyone who has experienced the delight of seeing them, as marvellous pictures, representing man's ideas about the world in which he lived. There could have been only two reasons for such paintings: to ensure the successful hunting expedition upon which their very lives depended and to have sufficient children for the continuation of the tribe.

No doubt there were rituals enacted at the same time as the paintings were being made and perhaps, it seems likely, that offerings were made for a successful outcome for the hunt. Stravinsky's ballet "The Rite of Spring", in which a young girl dances herself to death to ensure that the crops do not fail, is a memory of those times. Such rituals, which all the participants believed was for their very survival, have set a pattern in the minds of everyone since those ancient days. The idea of magic is very powerful and has come down to us as an inexplicable force; only comparatively recently has magic gradually been supplanted by knowledge. Magic was the answer for many peoples in remote parts of the world not so long ago.

I remember as a young man that I was present at the summer solstice (the ceremony of midsummer's day carried out by the druids) on Primrose Hill immediately to the north of Regents Park, London. The priests were dressed as druids in their full regalia. I had no means of knowing whether they were really committed to the belief that the sun ruled their lives, but they certainly behaved as if it did.

From the earliest days, burial of the dead was common, whether in large communities or small. They were, after all, burying their parents – and one's parents have been held in great respect by all peoples, in most countries. We know that we would not be here on earth without them. In due course, a new conception – that of Ancestor Worship and, in particular, that of male ancestry – arrived in many cultures at a similar time. As the male figure was the one who held total authority over the family, it was inevitable that this idea transferred to the head of the tribe and thence to the godhead.

Eventually, man's thoughts led him to the conclusion that perhaps it was not magic, but whoever had been able to create the world must have been a being far greater in wisdom and ability than he was. The being he imagined took many different forms throughout the world. Man was, from the outset, an individual. Each person was distinct (unlike the animal kingdom, which is hardly distinguishable in the same species, one from the other) and therefore the ideas about such a being who could create the world, the sun, the stars and man himself were also different. But the basic concepts showed a remarkable similarity.

Chapter 5
Mythology

5.1 Early Religion

Mythology carries with it the idea that supernatural forces, over which man has no influence, affect the lives of everyone either benignly or malevolently. The belief that the only way for human beings to bring about an improvement in the condition in which they live, was to ask those forces for their help; man would perform acts of worship which would encourage their particular god to look kindly upon them. Present-day rituals carried out by priests in all religions are a direct descendent of such thinking. These rituals, prayers and offerings, imply that we have had no control over our lives in the past and will not be able to do so in the future. This is I believe, a fallacy and was brought about as the result of our past ignorance. It is now time for us to correct such thinking.

Most people nowadays accept that the world of mythology was invented by men and in which we no longer believe. It is interesting because it demonstrates the versatility of men's minds in the distant past. An extraordinary range of mythical creatures and gods of all kinds was invented in every country of which we have a record. Some of these transmuted over time, moving from one country to another

and even transferring from a minor to a major god as a result of the great works they had performed. All had a defined place in the hierarchy of their particular heaven and had special powers and authority over different aspects of men's lives.

A complete record of all gods and goddesses is contained in a massive work, *Encyclopaedia of Mythology* produced by Larousse with an introduction by Robert Graves. Here I can deal only with a few of the major names in the most important countries which are dealt with in this book, in order to demonstrate the wide range of man's fertile mind.

5.2 Ancient Egypt

The Egyptians had a multitude of divinities recorded in a vast number of enormous sculptures, on small statuettes and on wall decorations carved into the stone of the temples, which record the activities of both men and gods. Their gods were in human form but with animal features, such as heads of animals and beaks of birds.

These divinities are often shown receiving obeisance from the worshippers and performing ritual gestures on the bas-reliefs and stone mummy cases. Many of the names of the gods are known, but in spite of considerable research, we know little about how they were worshipped or their precise responsibilities. Many animals were the object of veneration in different parts of the country, such as the cat, dog, bull and falcon. To kill one of those animals, even accidentally, was punishable by death. In India, even today, cows receive the same treatment and are allowed to wander at will.

The first tribes inhabited Egypt from the fourth millennium BC and we know that each tribe had a different god, which always took the form of an animal. This was before the invention of hieroglyphics and the stories about the gods were handed down by word of mouth from generation to generation. Gradually, the tribes amalgamated and started to live together in towns. At much the same time, their deities became transformed into beings with more human features.

They resided in their individual temples, which were not places of worship for the common people, but sanctuaries for kings and priests. Only pharaoh the king, who was called god's "son", was allowed into the temple to speak with him. High priests, however, could officiate on his behalf. They were a powerful priesthood who performed the traditional and mysterious rites pertaining to the cult. One of those colossal temples erected in the second Dynasty, the Temple of Amon in Karnak, is the largest religious building ever built and took two thousand years to construct. All the Egyptian temples demonstrate the high level of sophistication and technical ability achieved by those extraordinary people. Their civilisation of three thousand years outlasted those of both the Romans and the Greeks.

Imhotep lived in the court of King Zoser and is credited with being the greatest architect and the builder of the earliest pyramids. He is acknowledged as the first to use stone columns in his temples to support the structure above. Following his death, he was venerated and became the patron of scribes and of all who were employed in the sciences and occult arts.

The Egyptian writing – hieroglyphics - was carved in stone and does provide us with a unique opportunity to understand their way of both life and death. The French, under Napoleon, discovered the Rosetta stone early in the nineteenth century, which was not only inscribed in hieroglyphics, but also in Greek. This enabled a translation to be made; there was no other way that we could have read the Egyptian language, as it died out after the Romans took control.

All peoples believed in an afterlife and burials were often accompanied with the artefacts which the person had possessed in his lifetime, to take with him on the journey. These have proved valuable in assessing the degree of culture, the way of life and the social conditions at the time of burial. From the earliest days, the Egyptians carried out the remarkable practice of mummifying the dead and placing them in tombs, together with their most precious possessions. Most of these tombs have been opened and the contents removed during the many years which have passed, but a few important finds have been made, - most spectacularly that of the tomb of Tutankh-Amon with his golden mask.

Anubis, a jackal-headed god, presided over all embalming. The first to be embalmed was Osiris, whom Anubis bound up for the body to be preserved from corruption. His mummy was believed to have been resurrected by his wife and Osiris was responsible for all funeral rites thereafter.

We owe a debt of gratitude to Plutarch, who wrote about the myth of Osiris, the one god of whom we know the most, although the time about which Plutarch was writing was two thousand years before him. He was writing in Greek and

from a Grecian point of view, but we have the evidence of all the temples, carvings and hieroglyphics, which subsequently have shown that he was reasonably accurate in his records.

Osiris was believed to have been born in Thebes and, at his birth, a loud, mysterious voice proclaimed the arrival of the "Universal Lord". (This is my son, in whom I am well pleased?) The cult of the gods was instituted by Osiris, who also ordered the building of the first temples and taught the Egyptians how to bake bread and make wine. He was believed to ensure that the Nile rose and fell every year - essential if the Egyptians were to grow their crops. They never worshipped the Nile as such, as many other societies would have done. They did, however, have a river god named Sebek, in the form of a crocodile.

Osiris gave his people just laws and to have brought civilisation to the whole country, laying down the rules for religious practices. He then brought peace and prosperity to the rest of the known world, the Middle East and even India, by peaceful persuasion alone – not by military conquest, because he was against all violence. Plutarch records that, after reigning for thirty years as king of Egypt, Osiris was murdered by his brother - (we here recall the biblical story of Cain and Abel). Isis, his wife, searched for many years to find his body, which had been cut up into fourteen pieces. Eventually she found them after many detailed adventures and managed to join them together – even having a son by him, after she had resurrected his body.

Thereafter Osiris decided to reign in the world of the dead, rather than the living, together with his wife and posthumous son, Horus, as a trinity. Horus is depicted as a baby seated on his mother's lap, sucking his thumb.

(Mother and child – all these ideas are very reminiscent of the New Testament, written much later). Although such a normal action, the Greeks misinterpreted his thumb-sucking as showing his discretion, (not his youth) and this won the young god the divinity of silence; just one example that the stories were widely known – and also that they could become misunderstood. The campaigns of Horus are sculpted on the walls of temples. He was accused of being the bastard son of Osiris and therefore could not be his heir. The gods accepted his defence and restored him to become ruler of the two Egypts. Together with his father, Osiris and his mother, Isis, he reigned supreme. Osiris was worshipped throughout Egypt for three thousand years and there is no doubt that his exploits were known not only in Greece but generally throughout the Middle East.

His brother Set, who was the cause of his death, became the spirit of evil, whereas Osiris was considered to be everything that was good. In the guise of a black pig, Set was said to devour the moon every month, where his brother had taken refuge. After his death, Osiris was responsible for evaluating the conduct of everyone in the Elysian Fields and pass judgement on them, rewarding those who passed the final ordeal with eternal happiness.

The Egyptians believed that Ra, the god of the sun, created the earth and Shu, the sky. Ra was a newborn child every morning, grew to vigorous manhood by midday and aged to become a decrepit old man every evening. The sun was symbolized by the Great Sphinx of Giza carved out of solid rock in 2900 BC. The ruling pharaoh was also considered to be divine and the personification of the sun god, reigning on earth.

Khepri, the scarab god, represented life and the idea of eternal existence. Shu, a female goddess, was created by Ra without the need of a woman and is shown on a marvellous painting on a coffin, holding up the sky. Thoth, identified by the Greeks as Hermes, messenger of the gods, was worshipped as a moon god.

Herodotus, the first historian, regarded the Egyptians as the most religious of people. Every town, large or small, had a specific god to look after their well-being. The Egyptians were the first people to establish the length of a year, identified many of the stars and somehow managed to determine the orientation of north and south (without the knowledge of magnetism) from the movement of the stars.

Astronomy was an essential part of their religion, especially in ensuring the accurate setting out of the pyramids. They also invented the first pen and papyrus (paper). Some of these papyri still survive, one showing the lamentations of Isis over the death of Osiris. Another records the judgement scene from *The Book of the Dead* where Anubis leads a man, dressed in white, into the judgement hall and weighs his heart, in order to establish whether his soul goes to heaven or not, - "You have been weighed in the balance and found wanting". Their religious beliefs became common knowledge throughout the known world. They were the only form of culture available. Passed from mouth to mouth from Egypt to Greece, Phoenicia, Israel and Babylon, they formed the bedrock of everyone's existence – the first common heritage – and were totally accepted.

In all other ways, the Egyptians are the prime example of a static society. After three thousand years, they held no different ideas, nor ways of life, from those which they had

had at the beginning of their culture. They were a people who questioned neither who they were nor the reason for their daily activities.

5.3 Babylon

The Babylonian and Sumerian civilisations were founded in the third millennium BC and Babylon is the first society of which we have written records. Set between the two rivers, the Tigris and the Euphrates (in modern-day Iraq), "writing" was first developed, known as cuneiform. Small pieces of triangular wood were pressed into wet clay to form the letters. Hammurabi is credited as having issued the first laws in the city of Babylon, to ensure the safety and prosperity of the citizens – certainly one definition of civilisation.

Their idea of how the world was formed is contained in seven stone tablets, known as the Tablets of Fate, which, although made in the seventh century BC, must have been based on much older texts. Instead of recording god's commandments, as those of Moses in the Old Testament, the Tablets of Fate concentrate on natural elements, which controlled their lives. Water played a major role, as did earth, "Gaea", as in Greek mythology. Men who had been born were subsequently made into gods. The gods they worshipped and which were their explanation for the creation of the earth, were quite different from those of the Egyptians. Marduk, by his great exploits, although he had originally been a man himself, was believed to have organised the universe. He also moulded mud into the shape of a man and brought him to life using his own blood, similar to the story recorded

in Genesis. Men, having been created by a divine being, became the children of the gods. Marduk was the greatest god of Babylon and absorbed all other gods.

The Sumerian gods, although immortal, had failings as men. They enjoyed feasting and becoming drunk - and could even be afraid. At times, the goddess Ishtar became extremely violent and threatened that "the dead will become more numerous than the living". She was also the goddess of love and aroused amorous desire in all living creatures. Sacred prostitution was extraordinarily part of her cult and she was attended by prostitutes, courtesans and harlots. Small wonder that the god of Israel frothed at the mouth and forbade any other god than himself.

The greatest hero, who eventually became one of the gods as a result of his exploits, was named Gilgamesh. A poem is full of his extraordinary adventures, but does not, to my mind, have the character of those in the Greek epics, which came some years later. King Sargon of Sumeria revealed that he was born of his mother, a priestess who gave birth in hiding. She put her baby in a basket of reeds and sent him off down the river. Romulus and Remus, as founders of Rome, together with Moses, were all to follow in similar stories.

The Babylonians also had a tradition that the gods sent down floods and ordered one man to construct a great ship, to put all his family and animals aboard, including his gold and silver, so that they could be saved. This mirrors the Old Testament story precisely, even to the extent of the release of birds to discover whether the waters had receded sufficiently for them to leave the ship. In this case, however, it was the dove which returned to the ship, while the raven did not. The mountaintop on which they arrived is also placed in a

different location. We should analyse this story in greater detail, as it may help us to understand those ancient peoples rather better.

There were at least three different versions of the flood, which illustrates my point as to the telling of tales by mankind: one from Sumeria, now modern Iraq; one from Greece and the one we all know, in the Old Testament. These countries are all adjacent one to the other. There were no such tales from China and none from Western Europe. It is therefore impossible to believe that the entire world disappeared beneath the waves – or that mankind and the whole of the animal kingdom were saved by one man and his boat. This is such a marvellous invention, it is small wonder that it lasted over several thousand years. We learn it very early and it remains with us throughout our lives.

There can be no doubt that some event took place, which was so significant that it became the legend we all know, although exaggerated over time, being transmitted from one generation to another, from one country to another and over a long period of time, by word of mouth alone.

It is known that large parts of the Arabian peninsular were under the sea at one time. I myself, walking in the desert just outside Riyadh, three hundred miles from the sea in every direction, disturbed something beneath the surface of the sand. It proved to be a fossilised piece of coral. The sea level was obviously very different from what it is now and perhaps had changed more than once, within a short space of time. Recently, archaeologists have discovered the foundations of a complete town beneath the sea close to the coast of Greece. It is now an established fact that some sort

of inundation occurred in this area, which destroyed many communities overnight.

Prehistoric man had only one possible explanation for such a happening: that their god or gods were angry at the conduct of man and had decided that he must be punished. But, in order to demonstrate the great and beneficent god that he was, he relented so far as to save one man, his family and animals, so that the world could be repopulated. The three versions would seem to bear this interpretation out, but they all had different deities in charge.

It is almost impossible for people who have the facility of being able both to read and write, as we do, to put ourselves into the situation of being able to do neither. But we know that men have always had an inventive imagination. They could make up stories, based on some factual knowledge or belief – the more vivid the better. During my reading into ancient mythology, I have been constantly surprised at the great variety and intricacy of the lives of the beings they invented, but also of their basic similitude, one to another.

5.4 The Aegean Civilisation

Biblos, a port in Phoenicia, started to develop trade with other people, when the Egyptians sent their ships in search of timber and the resin they needed for embalming. The Phoenicians became the great traders across the whole Mediterranean. They called their god Ba'al, whose name we are familiar with from the Bible. The legend of Adonis and Aphrodite was also as much part of their culture as it was in Greece. This coming together of people from different

cultures resulted naturally in an exchange of the myths they both knew.

Prior to the development of Greece itself, Crete was the island from which the Greek religion originated, but this differed in one significant way from that of Egypt and Babylon, in that the chief figure was feminine; Athene. She was known as the Great Goddess and, as her name suggests, became the Protectress of Athens.

One of their legends which is most familiar, is that of Europa and the bull, actually Zeus in disguise, who carried her off and fathered the king of Crete; Minos. The bull was symbolic of the strength and power of the gods and later transmuted into the legend of the minotaur of Cnossos. This Bronze Age city and most of Crete itself, situated on one of the tectonic fault lines, was probably destroyed by an earthquake and tsunami in the sixteenth century BC. Bronze is a combination of ten parts copper to one part tin, - Crete had plenty of copper, but had to go as far afield as Britain and the tin mines in Cornwall to make the new metal. Trade across the Western world was extensive and eventually resulted in the Roman Empire. Cnossos was excavated by Sir Arthur Evans and provides an early example of the development immediately before that of Greece.

5.5 Greek Mythology

Greece produced a myriad of gods, all of whom were believed to be immortal and had magical powers of life and death. Their actions, however, closely resembled the conduct of ordinary men and women – including the ability to fall in love. A poem written in the eighth century BC sets out the

beginning of time. First there was Chaos, vast and dark. Gaea then appeared (the beautiful earth) and finally Eros, "the love which softens hearts". Gaea created the universe, bore the first race of gods and, finally, gave birth to mankind. In spite of those marvellous creations, she was superseded by Zeus, the father of the gods. Gaea was credited with being able to foretell the future for humans; she was worshipped and consulted in her temple, the Oracle of Delphi. She also presided over marriages.

The intricacy of the stories of the gods, which included the Titans, Giants and Cyclopes, their marriages, offspring and prodigious lives, is quite staggering. They are recorded in great detail in the epic poems *The Iliad, The Odyssey* and *Theogony.* They show the extremely high level of culture, which the Greeks had achieved at that early date and I shall mention only a few.

The Titans were the first people considered to be divine and were believed to have invented magic and the arts. One of the Titans had four sons, Menoetius, Atlas, Prometheus and Epimetheus, who played important roles in the creation of the world. Menoetius was cast into everlasting darkness (the first hell?). Atlas was condemned to stand forever on the edge of the world, supporting the heavens above. Somehow this has been transferred into the idea that he held up the world itself. This was clearly a follow up on the original story from Egypt with the goddess Shu.

Prometheus was able to foresee the future while Epimetheus received the gift of understanding the past. Prometheus fashioned the body of a man out of earth and his own tears; Athene breathed in life and soul. This event took place after all mankind had been destroyed by the great flood.

In another story, Zeus, the father of the gods, being in a rage, withheld fire from men on earth. Prometheus stole a brand of the holy fire kept on the island of Lemnos and carried it back to them. In revenge, Zeus ordered that a body of the first woman be created from clay, whose dazzling beauty would equal that of the immortal goddesses and bring calamity upon men. Zeus gave her as a gift to Epimetheus. This was Pandora, who was given perfidy in her heart and lies into her mouth by Hermes, the messenger of the gods. Prometheus, having the advantage of foresight, had warned his brother not to accept any gift from his father, but Epimetheus was enchanted by Pandora's beauty. She brought with her the gift of an enormous vase - (not a box). Pandora duly opened the vase and out flew all the evils from which mankind has suffered ever since - only hope remained. With the arrival of the first woman, misery and temptation arrived on earth – mirroring, for the ancients, the story of Adam and Eve. It is quite extraordinary for us, in modern times, to try to understand the minds of men who, at any time, could believe that as an act of faith. Where would they all have been without their mothers?

Strangely enough, Zeus was not always successful. Although he had been held to be omnipotent, many of the stories showed that he was not. Prometheus, with his gift of foresight, which Zeus apparently lacked, warned his father that a son would be born to him by his wife, Thetis and that this son would supersede him. Zeus immediately renounced his wife. Clearly, the Greeks accepted that a son was able to dethrone the father of the gods, - a most extraordinary belief. One of his divine functions was procreation and he enthusiastically associated with mortal women, nymphs and numerous goddesses. His offspring were legion, including the nine muses and the three graces. In order to ensure his

success with women, it is frequently recorded that Zeus changed his shape: a bull on two occasions, a swan and even a cuckoo. The reason for so doing is unclear, but it makes a good story. We must remember, that these were told across the generations, between cultures using different languages and are riddled with inconsistencies. One god may be responsible for a certain activity at one time and then may change completely. Sometimes they behave in a godlike manner, a being supreme. At another they will exhibit the natural failings of men, unable to bring about things they most urgently desire. All these tales, fantastic though they are, seem to represent man's needs and demonstrate that they believed that the gods were fundamentally of human origin.

5.6 Classical Greece

In the fifth century BC, Greek civilisation, their language, the written word, their insight into such extremely diverse subjects as philosophy, mathematics and medicine, were all far in advance of any other people. The example of the life of the philosopher, Socrates has been admired up to the present day.

The sculpture of Aphrodite, later to be known by the Romans as Venus, now in the Louvre, was considered to be the perfection of feminine beauty. The Greeks were also the first nation to produce plays, which are still performed. They constructed theatres; all the seats had a perfect view and acoustics, in spite of being in the open air. Only the Romans followed their example. Not only were the Greeks capable of producing original ideas in many different spheres, but they

also formed the first embryonic democratic society, which set the pattern for the future governance of all countries in the modern era. Their version of civilisation and their intelligent comprehension of the world was unique and it is somewhat surprising that they were not the first people to decide that they should worship only one god. They were, of course, not under the same pressure as Israel, to make them into a distinct nation. The Greeks were well aware of the contributions they had given to the world.

There is one curious situation in the development of Greece. The Greeks were pre-eminent in mathematics in the ancient world. Pythagoras discovered that a right-angled triangle had the property that the sum of the squares on two sides equalled that of the square of the hypotenuse. However, they did not investigate the circle to the same extent. As a result, the construction of their temples relied entirely upon horizontal stone beams to span the distance between columns, in order to support the structure overhead, as the Egyptians had done. This resulted in much closer columns in the interior. They did discover harmonics as a result of their ability in mathematics. The modern world has been in their debt ever since. The Sumerian culture did manage to overcome the problem of increasing the distance between columns and built many of their temples with arches - and even domes. These ideas formed the basis of Roman architecture and resulted in those marvellous structures with which we are familiar. Until the spread of Roman power, the design of buildings was a product of individual countries and did not pass between cultures. Mythology, however, travelled extensively and spread rapidly across the known world, due to the traders who took their goods and materials by sailing from place to place across the Mediterranean.

Their architecture was also quite distinct from any other. The only temples they built were in Greece and were originally constructed using wood. When they had perfected the design, they refined them in stone. The construction of their temples (notably the Parthenon built in Athens), their design and perfect form, has been one of the great wonders of the world. Although smaller than those of the Egyptians, they were built with such accuracy to the extent that they were able to correct man's imperfect vision. Each of the columns is slightly inclined from the vertical and at a minutely different distance one from the other. They were so designed to overcome the apparent effect of distortion: the columns would appear to be falling outwardly when seen from a distance, had they been erected truly vertical, due to the illusion of parallax. Later the Romans erected similar temples all across the Mediterranean and copied the Greek design perfectly.

The Elgin Marbles, - those marvellous sculptures by Phidias, (which decorated the frieze above the entrance), - were taken from the Parthenon by Lord Elgin in 1802. It is quite true that he was the first to recognise their importance - and the likelihood that they would suffer from further deterioration if allowed to remain on the building at that time. That is now no longer the case. The marbles should be returned to the superb new museum by the Swiss-French architect, Bernard Tschumi, so that they can at last be admired in the context for which they were designed. The museum is provided with state-of-the-art protection against further damage by pollution and is dedicated to their preservation. The sculptures, representing as they do, the extraordinary achievements of Greek civilisation in so many fields are, to my mind, significantly different from other items of antiquity, which are kept in museums apart from their

country of origin, that such an action would not presuppose that all others should also be returned.

With the arrival of world flight, everyone can have access to see them in situ, not only those who are able to visit the British Museum in London, so remote from their designed location. The British people should return them in gratitude for the Grecian civilisation, which has been of such benefit for the whole of mankind. The marbles are the unique example of the heights, which it had reached in those ancient times. Greek thinking, artistic pre-eminence and ideals, led the way forward to the way of life we all enjoy today.

The time of the Olympic Games in London 2012, would be the ideal opportunity for such an announcement to be made.

Chapter 6
Civilisation

6.1 Birth

When people gathered together in towns and acted in a civil manner towards those who were not their immediate kith and kin, they found that they could live in peace and prosper, if they wanted to. Until then, strangers, especially those from another tribe whose language they did not understand, meant only one thing, - danger - and were treated with great suspicion. Society, in this sense, has only developed in the last five thousand years. It is quite humbling to realise that there have been only two hundred and fifty generations of civilised society, as against those many thousands that went before. The speed of advancement has increased incrementally since the advent of town life – due originally to the discovery of fire and then being able to adapt and live settled lives in a larger community.

Civilisation was originally based entirely on the acceptance of tolerance towards others, no matter how different their religious convictions may have been. There is no evidence that there was ever any antagonism between people who believed in the gods of Egypt and, for example, those of Greece. Both nations accepted that people could worship any god they wished.

The ancients had little scientific knowledge and they needed to have an explanation for the conditions in which they found themselves. It was inevitable that the idea of a beneficent supernatural being, who could improve their lives, should have been created by mankind himself - there was no other answer possible at that time. However, over a long period, it became apparent that they themselves were able to bring about improvements by their own actions, but those original ideas in search of a creator remained unchallenged.

Persons entrusted with giving out their god's instructions and who were therefore believed to have direct contact, were inevitably regarded with awe and they no doubt elaborated their message over time to maintain their authority. They ensured that their followers understood that it must be god's wish that men duly acknowledge him and give thanks for their lives and prosperity. From this, once accepted, everything else follows naturally, man being the imaginative and creative creature that he is.

6.2 The Roman Empire

Since the formation of towns, there have been many attempts to amalgamate cities and nations by conquerors, starting with Alexander the Great.

In 336 BC, King Philip II of Macedonia died. His son, Alexander, took the throne and immediately commenced with a series of conquests, overpowering an extraordinary swathe of the present-day Middle East, up to the borders of India. His empire lasted a very short time and broke up after his death in 323 BC, when he was thirty-two. He was followed by the Romans and, in particular, Julius Caesar,

who turned Rome into an enormous Empire, spanning Turkey, Egypt, Gaul (France), Spain, northern Africa and as far as the north of England. This allowed many different peoples of a wide range of nationalities, languages and religions to live together in relative peace, security and prosperity. Romans, together with many of the different nations they had conquered, were granted citizenship rights and even slaves could win their freedom. The people were the more easily able to be assimilated because of the common language of Latin, an essential requirement for men to live together.

From the start, following the disappearance of the Etruscans in northern Italy, the Romans showed themselves to be an intensely practical people. It is no surprise that they were as successful as they became. In all other respects, they were less inventive, preferring to take over ideas – social, philosophical, religious and architectural – from not only the Greeks and Egyptians, but even the Sumerians.

There were many Greek colonies at that time in Sicily and southern Italy itself, so there was a cross-fertilisation of all ideas, especially of religions. The first concept of a powerful Empire also arrived and lasted for over five hundred years, until the barbarians sacked Rome. Such a long period of time, during which there was a degree of freedom and security for ordinary people, allowed the development of an infrastructure: communication systems which had not previously existed; roads, bridges and viaducts for water to be delivered to towns for everyone within the Empire. The primary reason for such an extensive development was to ensure that the Roman army could move swiftly to any part of the empire for security, but it made a great contribution towards trade and the progress of civilisation. No other

country had attempted such an amalgamation of different peoples and succeeded.

Those years of peace and prosperity were not to be repeated until the nineteenth century under the British Empire, when Pax Brittanica similarly brought a period of calm to the world for a century or more.

The Romans, being a practical people, had a different understanding of their divinities from any others. Their deities were regarded as protectors for whose services they paid. In the case of failure by the god to perform, his wages were withheld – a truly modern idea. In no sense could this be considered as worship. This attitude reminds me of something I was once told: that the Chinese used to pay their doctors to keep them well and immediately ceased once they fell ill.

There are few original Roman gods. Most are of Greek origin, although their names were Romanized. Mars was probably the most Roman of gods and, although originally considered to be the god of agriculture, transformed into the god we all know, the god of war. He was also the father of Romulus and Remus and therefore became the great god of Rome itself. The twins were suckled by a she-wolf when abandoned in a basket on the river Tiber (reminiscent of the story of Moses in the bulrushes). In an argument as to which brother should have the privilege of setting out the boundaries of the city, Romulus killed Remus - (shades of Cain and Abel). After his triumphal success, Romulus took advantage of a festival called "Consualia" and carried off the Sabine women. One Roman god, who appears in no other mythology, is Janus, who was the god of entry and exits, not only of the house, but also the city. For this reason his name was also adopted as the first month of the year, January. He is usually shown

as having two faces and hence was able to guard both sides of the house at once.

Their development of a much simpler alphabet than that of Greece, was a massive advance towards civilisation. Roman lettering, incised into Trajan's column in Rome, is regarded as the most elegant ever devised. Students of design are still required to study and copy its perfection, to stimulate their sense of proportion and precision. Following the conquest of the majority of Western Europe, their alphabet was used throughout the Roman Empire and has remained our common heritage throughout the last two thousand years.

Roman numerals, however, were a great bar to their understanding of mathematics. The world had to wait until the Arabic invention, in the twelfth century, of numerology, including the use of zero, for any advance to be made in calculation. It is amazing that the Romans could build those great bridges, huge viaducts spanning wide rivers - and the Colosseum itself, having to use such an imperfect system. Many of their structures still exist; the barbarians were not capable of demolishing the greatest viaduct of the Pont du Guard at Nimes, although they certainly tried. There are few structures from that period, which have remained in such a perfect condition.

I lived for a while in the town of Arles in the south of France. This was founded by Julius Caesar and is the most perfect example of a Roman town I know, which is still functioning. Anyone who wishes to experience something of the life people lived in the Roman era, must go there. The streets are as they were in 50 BC, just wide enough for a chariot. The one-way system now in place, was the same for the chariots, with no parking.

Aerial Photograph of Arles

Caesar, being the supreme soldier that he was, chose the ideal defensive position; to the west is the fast-flowing river Rhone. To the south is the delta, a large expanse of mud flats – now a national park, the Camargue – and to the north a hill. He succeeded in providing complete protection from the sea. The aerial view of Arles is facing due north. The river Rhone flows from north to south. The Camargue and the Mediterranean lie twenty kilometres to the south. The arena and theatre are in the centre of the town, but there is no Grecian temple. The nearest is the Maison Carrée in Nimes which is the most perfectly preserved example of the genre throughout the Mediterranean. Some of the enclosing walls still stand, as well as the only entrance gate, which is on the northern side. Both the arena and the theatre not only remain, but are still in use during the summer months. The Roman cemetery, Les Alyscamps with its avenue of trees, has also been preserved and was subsequently painted by Van Gogh.

Chapter 7

Monotheistic Religions

All of the characteristics of mythology and the foundations of religion are included in the three main Western versions and their many spin-offs.

The Jewish, Christian and Islamic religions all originated from the deserts of the Middle East. This is unsurprising; those who have experienced being in a desert know that its power of suggestion is formidable. The over-powering sense of space, the distant horizon, the enormity of the sky, the intense heat of the sun and lack of shade, the infinite nothingness, – all make the person feel deeply, especially when alone.

Questions of the reasons for man's existence – why he was created so distinct from any other animal - and to where was he going – demand answers.

7.1 Judaism

Three and a half thousand years ago, the Judaic faith, one can only suppose, took a positive decision to reduce the number of gods from the many known at that time in Egypt and Greece, to a single being. They were an intelligent people and had good reason for such a development.

The Jews came to believe that they needed special assistance simply to survive. They accepted that their god had chosen them and them alone, - that their religion with one supreme god, was created to teach other peoples, who had many gods, the moral way of living. To be told that the Jews were a distinct people, different from any others, gave them a superiority, which they would not otherwise achieve. This is the reason for their continued wish to keep themselves separate throughout history. The curious rite of circumcision, upon which great stress was placed, again made them unique from any other nation.

Manuscripts appeared soon after the invention of writing and retold the early history of the travails of the Jews, which eventually became the Old Testament. Some of these have been discovered and translated; they are known as the Dead Sea Scrolls and are, without doubt, extraordinary documents. They were the result of the transmission of those tales by word of mouth over hundreds, possibly thousands, of years.

Some may have been based upon historical fact, but those have been exaggerated for the reasons about which we have already spoken (in the formation and keeping together of the tribes of the distant past), with the clear intention of ensuring that the Jews, who were inferior to other counties militarily, remained one people. They had been the subjects of many different nations – the Assyrians, the Egyptians, the Huns, the Greeks and the Romans, to name only a few.

> *"The Assyrian came down like a wolf on the fold*
> *His cohorts all gleaming in purple and gold"*

In the many years since that time, this distinction has also made other nations keep them apart from their own people, - in ghettos (as in Venice, the origin of the term). It was not only Nazi Germany who persecuted them without mercy. Many other nations, although welcoming their ability in financial matters, still found it impossible to assimilate them. It is small wonder that the Jews are determined to survive and feel that their only security lies in their own strength, vigorously resisting any attempt to subjugate them again.

All religious organisations, be they Christian, Moslem or Judaic, make the same promise to their flock that, in addition to survival here on earth, - "Only by following our precepts can you achieve an everlasting life in heaven – otherwise you go to hell."

An outside observer might reasonably conclude from this, that these three religions would be able to work together towards a common goal. They agree that they serve the same god, after all. What, one wonders, would he have made of those irrational differences? One assumes that, being the intelligent creator of the whole of life on earth, god might have shown his displeasure in some way, to get them to return to the way of truth. "Thou shalt have none other gods but me." I said that the three religions worshipped the same god, but that is not completely true. Jehova, the Old Testament god of the Jews, was the embodiment of a god who acted, as the Bible continuously reminds the reader, as if fear alone was sufficient to keep his followers faithful. Everywhere throughout the Bible is recorded his wrath, which people had brought upon themselves, in spite of the many benefits given them by god, due solely to their sinful ways.

Here we remember the story of Sodom and Gomorrah and the destruction of those cities as a result of their peoples' depravities. Only Lot was allowed to escape. His wife was turned into a pillar of salt simply because she turned back to watch, an entirely human response. Who would not have wanted to see such an event?

It is unclear the reason for her demise, given that her transgression was of such a minor nature. There could only be one answer, as announced by the priests: that god was the master and his servants had to obey his orders, whatever they might be. The Old Testament is entirely negative in its portrayal of any other way that people's lives should be lived. No mention is made of the value of love, human kindness or toleration of others, in the Ten Commandments or anywhere else.

7.2 Christianity

From the outset of Christianity, great stress was placed upon those qualities as portrayed by Christ.

The one person who effectively abandoned his religion of Judaism and made a clean break with all its strict requirements necessary to be a Jew, (even that of circumcision), was Paul. He never met Christ, but is regarded by most people as having founded, almost on his own, the Christian religion. Following his conversion on the road to Damascus, he travelled extensively across the Middle East as the first missionary and recorded his messages in letters (epistles) addressed to the towns where he had preached. There is disagreement as to how many of these are actually by Paul.

For example, Paul appears to change his mind as to the place for women in religion, saying originally that they are to be regarded as the equal of men and later, that they are subservient. Verse 5, Chapter 11 of the First Epistle to the Corinthians, requires that a woman must cover her head in church and, in a later verse, states that woman was made for man. Verse 34, Chapter 14, demands that women keep silence in church. This has caused great problems since those days and is responsible for the continuing debate as to whether women are able to become priests and celebrate the mass – the effective reason for the continuing disagreement between the Roman Catholic and Protestant Churches. The whole of Chapter 13 concerns charity and is frequently used during the marriage service. It seems probable that there was more than one hand at work. Whether or not Paul was the author of all his letters, we can assume that somebody evolved the ideas about Christ and why he was to be regarded as a god.

After Christ's death on the cross, Paul constructed a method of incorporating Jesus' ideals into his version of the new religion, while trying to keep to the original idea of there being only one god. It seems to me, however, that two new gods were added: Christ, the Son of God, who was made man - and the Holy Ghost. They were to be called the Trinity, - (an amalgamation of three different gods) and was an ingenious device.

Even so, it was close to falling foul of Jehova's strict requirement that there should be only one god: himself. We here must remember that there was an earlier version of a Trinity ruling in heaven, - that of Osiris, Isis and Horus in Egypt some thousands of years before. It is hard not to

draw the conclusion that this idea, like so many others, was borrowed from the past.

As we have seen from the days of mythology, men, who had been born of woman and lived on earth as ordinary mortals, were frequently made into gods. They lived on in heaven after their deaths because of the wonderful things they had performed for the benefit of mankind. It is revealing to recognise that Christ was similarly transformed. Christ, however, never claimed to be godlike, only that he was the son of his father. I assume he meant that we are all sons of god, as was believed from the earliest times.

In order for Christ to be accepted as a god by men and women, Paul thought it was essential for him to be credited with miraculous powers while he had been alive. For Paul to have decided that the first miracle, which Christ performed, was the changing of water into wine – at such an ordinary event as a wedding – was a stroke of genius. Everyone attends weddings from their earliest youth; they are the centre of family life throughout the world. We would all like one of the guests to be able to do that. It was a natural follow-up; that Lazarus was raised from the dead; that the blind should have their sight restored and that it was possible, through faith alone, to be able to walk on water.

The birth of Christ had also to be quite different from any other man and there could be no greater distinction than that his mother was a virgin, that his birth should be announced by an angel from heaven and that kings should bring gifts of great value and rarity to his cradle. It was also a brilliant idea that he should be born in a manger, surrounded by farm animals. Such a birth would not only appeal to the rich, but also to the poorest of the poor. All these miracles and stories

are memorable and intended to prove, that the person, who was born in such a condition and who could work such wonders, was certainly a god who was indeed worthy of worship by everyone who heard his message.

It is worth drawing attention here to the fact that the gospels of the apostles differ one from the other. For example, Matthew records the virgin birth and Christ's family life from an early age. The second gospel Mark, however, starts at the time of Jesus' teachings. For him to omit such a remarkable birth is surely difficult to explain in any other way, than that it was an addition to the original story.

Paul was of his own time, but he was also an independent, original thinker. Nowadays, we do not transfer those great men and women who have lived extraordinary lives, such as Gandhi, Nelson Mandela and Martin Luther King, into supernatural beings. We give them due honour and try to think of what it would have been like, to have lived as they did.

It is enough for us to know that Christ was an innovator, that he could see that the Jewish faith had been corrupted - ("you have turned my father's house into a den of thieves") and - most especially, that he wished men to live in peace and to love one another. His message, two thousand years later, has still not been fully accepted by the many variations of Christianity. We do not need to believe that he performed miracles, that he rose from the dead on the third day, nor that his mother was a virgin – in order to understand his approach to life. We must think the more of Christ, if we are certain that he was an ordinary mortal, as we are.

Paul, in order that the message would be accepted, required the addition of the New Testament to the Bible, written

later and dedicated to the history of Christ's birth and life. This attempted to prove the case by demonstrating a very different approach as to how people should live their lives from that in the Old Testament. By such means, a collection of followers was attracted to this new religion, especially women and slaves, who had previously been largely excluded. Hence the arrival of the mother of Christ, the Virgin Mary, very close to being a fourth part of the godhead. This took a rather longer period of time to come to pass than might be imagined. It was only with the completion of Chartres cathedral in 1260, (which was named after her), that this cult took off.

Paul decided that Christ should be remembered by his followers, by the communal breaking of bread and the drinking of wine, as was thought to have taken place during Christ's last meal with his disciples, - a very pleasant idea originally. This, however, subsequently developed into the mad belief of "transubstantiation", that the bread used in the Mass, was transformed into becoming his body - and the wine, his blood. Paul was obviously desperate to make a complete change and make his new religion unique – and he succeeded in convincing many millions of people. It is quite incredible that such a bizarre belief should still be held today, two thousand years later.

Cannibalism is rightly regarded with horror by every society, which claims to be civilised. Cannibals eat the enemies they have killed, perhaps to take their power and strength – the same reason given for the mass or communion. And it is even more surprising that Christians still believe it – the power of belief without any possible justification.

From the moment of my confirmation, I found that this was such an unpleasant rite and completely meaningless, especially because it was carried out with the priest clad in antique robes. For me, it was as if I had been taken back to an uncivilised society in ancient times, whereas I wanted to live in the twentieth century.

7.3 The New Roman Religion

Christianity was adopted as the new religion of the Romans by Emperor Constantine in AD 313. He decreed this change as a matter of policy rather than a personal conversion, to enhance the power of Rome. Previous emperors had all been worshipped as gods and it was an extremely abrupt diversion from the original founders and their republican philosophy. The Roman feast of Saturnalia was observed from 17–23 December and was the occasion when slaves were waited upon by their masters and were able to do and say anything without restriction - a period of unrestrained licentiousness.

The leaders of the new religion decided to retain the dates of the feasts of pagans for their ceremonies, because they had been observed throughout the Western world for many years - and selected that period as the date for the birth of Christ. The Romans had always been prepared to adopt the latest ideas that would strengthen the Empire and the majority of the western part of the civilised world gave up their adherence to the old gods, transferring their faith to Christianity. If they could do that within a relatively short period when travel between peoples was so difficult, then we,

in our time of immediate communications, should be able to give up our religious convictions much more quickly.

Christianity proved to be essential for civilisation to survive during a period of several hundred years following the fall of the Roman Empire, known as the Dark Ages. The northern peoples, who had not been subjected to the Roman influence and were by no means Christian, roamed Europe in search of rich pickings and wives. With no Roman army to prevent them, the Vikings and others, sailed at will, plundering, raping, rampaging and setting fire to whatever they wished. Civilisation was on the point of being lost. The only safe places were tiny, remote islands off the coast of Britain. These, - such as Iona and Holy Island, - were selected by the people with education, the monks, who were there able to worship god in peace. At the same time they produced those incredible works of art, the illustrated manuscripts such as the Book of Kells. Without those monks in their monasteries, it is quite probable that Greek and Roman philosophical, historical and social records, with all their understanding of life, would have been forgotten.

We would have been deprived of a huge volume of ancient literature, which the monks kept and translated for us to appreciate. As Kenneth Clark put it, - in his magnificent documentary, *Civilisation,* - we got through by the skin of our teeth. Eventually, Europe settled into relative peace and the Mediaeval period produced an entirely new society of feudal peasants and local lords ruling over them, with Christianity as their common thread.

The world of religious architecture is truly astonishing: that a generally uneducated people could construct the vast Gothic cathedrals throughout western Europe at that time, with no

more than the power of horse and man, is quite remarkable. They would be immensely difficult to build even today, with all the mechanical advances now at our disposal. The motive, clearly, was a deep desire to show how devout they were – and also that they were more religious and powerful than their neighbours. Competition was as much a force then as it is today. They were constructed to convey one message only: that God is supreme. Everyone must bow the head and kneel to the almighty when entering. No one was allowed to have any other thought in his mind.

7.4 Islam

Another new religion was founded by Muhammad, - again in the Middle East, - in the tenth century. He ignored Christ, whom he regarded as one of the minor prophets and reverted back to the God of the Old Testament, writing a new version of it, the Quran.

Muslims believe that the Quran is God's greatest gift to humanity; it is a book like no other. In the second verse of the second chapter of the Quran, God describes the Quran as "A book whereof there is no doubt, a guidance for those who are pious, righteous and fear God". How God came to give this testimonial to Muhammad is unclear. Since that time, efforts have been made by sincere Muslims to demonstrate that the writings recording the life of Christ in the New Testament have been fabricated. Recently, Christian scholars are quoted on one Muslim Web site, as confirming that much of the New Testament was invented.

The intention of the Islamic religion is clear - to convince their adherents that Islam should be accepted rather than

Christianity. Of course, all it does is to demonstrate that, while the New Testament was indeed largely made up, it does not prove at all that Muhammad was told by God, what to write in the Quran. Both books were the inventions of fertile minds.

Judaism has been questioned by Islam in much the same way. Both religions agree that the basis for their two beliefs is identical: that there was one god who created the universe and mankind. If so, I do not know how he feels about the division which has come between them, nor understand why neither wishes to reach out to the other in friendship.

None of the three major religions of the West accepts any of the others. They all try to keep themselves as distinct as possible. None will give the slightest hint that they themselves may be wrong, only (gleefully?) pointing out the defects in the other religions, of which there are indeed a large number of choices available. One might ask, to quote the Bible (a most dangerous thing to do), as to whether it is not rather a question of motes and eyes?

We must however, admire and be grateful for, those superb buildings and gardens constructed in Spain by the Arabic race, such as the Alhambra. The gardens, which they considered to represent Paradise, are a marvel and have never been surpassed. There is a strong tradition that, during the time when they were in control of Toledo in Spain, there was complete tolerance of all religions, Christian and Jewish alike, with no form of discrimination. Perhaps Islam will be able to recapture that approach soon.

7.5 Dissemination of the Faiths

There are extreme differences in the way all three religions go about encouraging (or not) outsiders to join their faith. Judaism does not try to attract anyone who was neither born nor married into their religion. They keep to themselves, protecting their faith by exclusivity.

Christianity followed Jesus' teaching, "Feed my sheep" - and they were not only concerned with their own sheep. Following in Paul's footsteps, the Christian Church vigorously sent their missionaries out to preach the message that salvation is only possible through following Christ. Many went abroad, believing that god had called them to propagate his work. One wonders if they could not have stayed at home and prayed. In particular, they went to the continents of Africa (mainly Protestants) and South America, (where there were only Catholic priests, since that area was largely occupied by the Spanish conquistadors).

Islam seems to have spread without the need for missionaries. From the north of Africa to the south of Spain, Islam offered only death as an alternative to accepting the faith. Elsewhere, mainly in the Western areas of the Java Sea and Indonesia, it proceeded to attract members by word of mouth alone.

Wherever the various religions went, the result was the same – complete polarisation – and they all rigorously refused to permit influence from other religions. They preached that theirs was the only true faith.

Islam split into different factions, as Christianity was to do several centuries later.

Two special groups, - the Shiites and the Sunnis, divided in AD 931, when they disagreed as to the ancestry of Muhammad. Since that time they have both held sway over different countries: the Shiites in Lebanon, Iran and Iraq: the Sunnis in Saudi Arabia. Osama bin Laden is a Sunni and his antagonism against the West, especially America, is well established.

This extreme and exaggerated difference between the two sects demonstrates very precisely the failure of religion to unite; it only divides. Their attitude towards each other, reminds me of the satire *Gulliver's Travels* by Jonathan Swift. In Gulliver's first voyage, he goes to Lilliput, the country of little people. He becomes involved with the Lilliputians in a battle against adjoining people. After helping them to win, he asks everyone what was the cause of their disagreement. No one could tell him; they had always fought against one another. At last one old man remembered: they had disagreed over which end of a boiled egg should be opened, - the big end or the little.

Here is another satire, - a modern joke registered on the Internet:

> *The Pope died and knocked at the pearly gates. St. Peter asked him who he was. The Pope said, "I am the head of the Roman Catholic Church, the leader of two billion Christians. I expect to enter." "Well," said Peter, "I must ask god first." He returned and said that god was not sure and had gone to talk to Jesus. Jesus was heard to burst out laughing and told god, "You remember that fisherman's club I set up two thousand years ago?"*

A new sect, - Bahaism, was formed in 1863 in Bagdad by Baha Ullah, from the Shiites. Bahaism does not contradict the sciences and stands for:

- Unity of all religions
- Universal education
- Equality between men and women
- International language and government
- Service towards one's fellow man

This is certainly a great leap forward from the social conduct of the others, but unfortunately, it also preserves their original belief in the prophets Abraham, Moses, Christ and Muhammad. Because they all preached such different things, it is difficult to understand how the sect can altogether believe in the list, desirable though it is.

Every church, mosque, synagogue and their priests practise diversification. They each maintain that theirs is the only true religion, that all others are beyond the pale and must never even be visited, certainly not married into, let alone followed. Religions do not want - and fear, contamination with another faith and they only accept each other with extreme reluctance and under strict rules. Men, being what they are, will of course marry into another nationality, colour or creed when they think that the girl is the one they most desire. But in the past, there have been extreme difficulties put in their way. No longer: they simply intermarry or leave the Church.

Perhaps this is why the act of marrying is on the decline – another reason, to my mind, for all religions to abandon their present stance. Marriage - and the consequent raising of children in a stable environment, is one of the greatest

contributions to human society throughout the world. It has always proved to be so since civilisation began, whatever the religious divide. I trust it will continue.

7.6 Composite Religions

The day Martin Luther hammered the nail into the church door to hold up his ninety-five articles in 1517, he probably thought he was hammering the first nail into the coffin of the Roman Catholic Church. The sale of "indulgences", that one could pay money to the church to ensure that one's sins would be forgiven, was especially mortifying to him. It is certain that, from that day onwards, the church split into the Protestant group of religions, amongst which were national churches, including those of Germany, Switzerland and England. However the Catholic Church survived in France, Spain and Italy, - soon spreading westwards with the discovery of the Americas. Johannes Gutenberg invented the printing press in Germany. The first Bible was printed there in1455 and the invention spread rapidly across Europe – in due course taking Protestantism with it.

Having started as a set of national churches, Protestantism fragmented over time into a number of breakaway sects, some of them not much more than cults. Most of these were founded by one individual with unusual beliefs, - that he had become convinced were the only way to save the world.

It is quite impossible to relate them all and they are still being formed. I cite only the most bizarre – and they became more so, as time went on.

The **Amish** people, who fled from Switzerland, live in America much as they did in Europe in the seventeenth century. They have no mechanical aids to help them in the fields (they are a farming society), they use no form of transport other than horse and cart and they allow no intermingling with their neighbours. It is said that recently some sects are prepared to install electricity, but quite how they can square their consciences with such a modern invention I do not know. We live in a tolerant society and they of course may live how they please, but I am most concerned about the children. They have been given no such opportunity to decide for themselves. One positive thing to be said on their behalf is that they practice tolerance towards their fellow man and would never be involved in going to war. They are the ultimate pacifists.

Another sect was the **Mormons,** the Church of the Latter Day Saints, who were formed by John Smith in 1830. He had had a vision that a group of Israelites had migrated to America centuries before the birth of Christ. How he thought they could have done that is unclear, but his followers apparently did not question him on the subject. He also told them that the Second Coming was imminent. He must have been a powerful orator because he persuaded a large group of people to leave in their wagons and travel hundreds of miles to a new part of north-west America and settle in Salt Lake City. There was no harm in that. Many people left their homes in the east at that time to move to the new frontier. But John Smith had an ulterior motive. He wished to do the unforgivable and persuaded his followers to carry out - polygamy, that most odious practice where the elders are able to have several wives. Of course, these tended to be the young unmarried daughters in the sect. Again, the girls had no power to say no. How he could get normal,

law-abiding Christians to follow him in such a manner is astonishing. This practice was recently made unlawful by the American government, but there have been rumours that it has not entirely disappeared.

One other sect, whose name I have forgotten, was responsible for the mass suicide of men, women and children in three different countries: America, Canada and Switzerland. They believed, on what evidence I know not, that the world was coming to an end on one particular day and decided to forestall the event. They locked themselves in a room and everyone took poison. Yet again, the children were given no choice; their young lives were at an end before they had experienced anything of the beautiful world into which they had been born, due entirely to their parents' mad beliefs.

The question must be asked: How is it possible for any intelligent, well-educated person to follow one man – for instance, John Smith; the leader of the unnamed sect, or even Hitler – and carry out actions which one would have thought were totally unacceptable to anyone at all, let alone to those who claimed to be religious? To be strong enough to say no when in a group of people is extremely difficult. We must learn to say no much more often, whenever someone in authority suggests that the group does something, which is unacceptable to oneself.

All religions have a lot to answer for. They seem to be prepared and are able to manipulate their adherents to behave in an extreme way towards their fellow man and even their own children, believing they are obeying their god's wishes. Perhaps religion should be considered as some sort of hallucinatory drug, under whose influence people are quite prepared to commit the unthinkable. It will take several

generations, before even a dent is made in the numbers of people who accept their religious authority's instructions without question, that it is "god's will".

7.7 Religion in China

For one who had not known anything about either Taoism or Confucianism, I found it most interesting to note the great differences between them and the Western religions.

There is even some doubt as to whether they should be regarded as religions at all, because they hold no allegiance to any god or gods. They accepted, two thousand five hundred years before Darwin, that the earth evolved naturally - and that included man himself. Their emphasis lies almost entirely upon the value of filial piety and continued acts of respect towards departed ancestors. It is not even necessary to carry these out within a special building, but they do form an important part of ceremonies such as weddings, funerals and initiations of the young. Reverence for nature in all its forms has had a major part to play amongst the Chinese ever since.

Confucianism arose five hundred years before the birth of Christ and is a philosophy that places great stress upon the ethical, moral and social values by which life should be lived. It was eventually made the official state culture in the Han dynasty.

In 1912, the new Republic of China officially abandoned all religions as being feudalistic and emblematic of foreign domination - and said that atheism was the only acceptable way of life. This seems to have been a rather curious decision

because Confucianism was hardly feudal, not at all of foreign origin and did not believe in any god.

Recently, something of a revival of Confucianism has taken place, although China officially remains atheistic. Of all the religions I have studied, it seems to me that it has much to recommend it. As always, perhaps we have something to learn from the Chinese: their civilisation started much earlier than ours.

Chapter 8
Roman Catholicism

8.1 Origin

Because it had originated in Rome, Latin was used for every church service. This helped the church to control their adherents and hold them together. In every country one could follow the service, which was identical throughout the Catholic world for two thousand years. It is difficult to explain that the one thing which was common to all and had performed so well, was recently altered, - especially so, since they are normally against change of any sort. Now a different language must be used in every country. Perhaps they have realised that pride in national languages had become more important and had held peoples together better, than religious belief?

The Church became one of the most powerful organisations throughout the world, transcending nation states and Emperors alike. In AD 800 the Pope crowned Charlemagne the Great as Emperor of the Holy Roman Empire, thereby demonstrating the supremacy of church over state. The person appointed by god to be his messenger was above the merely temporal power of an emperor - and so it has pretended ever since. Religion expects that the faithful, who attend a religious service every week and receive god's

message, behave themselves; that priests, who had received the best education available and were some of the most intelligent of men, would certainly obey its commandments. It does not seem to work out that way. Rodrigo Borgia, Pope Alexander VI (reigned 1492–1503), simply bought the Papacy outright and proved as close to the prince of darkness as human beings are likely to come. It was said that he could have filled the Sistine Chapel with the gold he acquired. These are the words of the eminent American historian, Barbara Tuchman, in her book about this period, *The March of Folly*.

The Pope is infallible when speaking "ex Cathedra". A group of men, who can unilaterally decide, without any evidence, that there should be no advance, no change at all to the accepted ideas of the Church, is hardly the way towards improving the lot of mankind. If there were a god, I cannot believe he would have preferred men to remain in the same condition as the animals in the field. According to the Old Testament, god gave us freedom of will and a brain, both of which he must have expected to be used.

It is impossible to understand how the Church, founded by a man such as Christ, could not believe in change. It was Christ who wished to change the entire way of life and thinking of the Jews.

The Roman Church however, has fought for the whole of its existence against change in any field, particularly scientific advances. It requires its adherents to believe and accept its dogma without question. We know that Galileo Galilei was forced to retract his statement that the sun was the centre of the planetary system, not the earth. He knew this by research through the telescope he had invented, which was simply for

the purpose of knowing the name of the ship coming into Venice before anyone else, - something that was of great financial benefit to the person with the telescope. Venice was at that time the greatest port in the Mediterranean and made Italy able to dominate trade throughout Europe for many years – and incidentally, helped to fill the coffers of the church.

In 1610 Galileo turned his new invention upon the night sky and was the first person to see the moon's surface in great detail. He went on to write a treatise on the planetary system and proved that, indeed, the sun was the centre of our universe. This brought him into immediate confrontation with the Pope, who ordered the Inquisition to question Galileo. Threatened with torture (no idle threat at that time), he decided to recant. The power of the Church was used then and continues to this day, to try to prevent changes in man's knowledge and improvements in his way of life. I am unaware of any apology from the Catholic Church to the scientific community. Unsurprisingly as a result, although Galileo is remembered as the Father of Modern Science, there were no new inventions or theories advanced by Italian scientists - and all future scientific research passed to Northern Europe, the Netherlands and England.

8.2 Contributions to Civilisation

It is fully acknowledged that there have been many great contributions made by religion throughout history to advance the cause of civilisation, in particular the worlds of art and music. To attend and hear plainsong in a Romanesque monastery is indeed a very moving experience and it is easy

to understand that the religious feelings then generated are deeply felt. They are a normal human response, but they imply only an appreciation of life, shared one to another. I have also heard a marvellous performance of Mozart's *Requiem* in a Romanesque church in an exquisite hilltop town in the Luberon, Provence. These towns are as much a joy as those in Tuscany. They were of course, built at the same time, by the same people and for the same reason, - protection.

One very hot evening, several hundred people, including many young children, who behaved perfectly during the two-hour performance, crowded into a small church, with more listening at the open doors. An orchestra and chorus of some twenty singers crammed themselves into the apse. It was a memorable evening indeed, for us all. A great conductor is credited with saying, "If you have Mozart to worship, why do you need a god?"

From Vivaldi onwards, miraculous music has been written which would not have been created without the composer being religious. As against that, Beethoven's *Ninth Symphony*, specifically "Ode to Joy", is a triumphant hymn to mankind; it contains the words "All men become my brothers" and "I embrace the World". For this reason, it has been adopted by the European Union as their international song. Erasmus also said "My country is the world." Those are the words every human being should surely subscribe to.

The popes, cruel and irreligious though they were, felt the need to show off their power by commissioning such a genius as Leonardo da Vinci and many others to paint and sculpt great works of art. St. Peter's, originally designed by Michaelangelo, was completed by Bernini. His great portico

encloses, in two vast semicircles, the area where the faithful can gather to hear the Pope's message "Urbe et Orbe". The space thus created is truly breathtaking. The Sistine Chapel is another of the greatest wonders and the world would have been deprived of the magnificence of its ceiling, had Michaelangelo not been instructed by the Pope to record his understanding of Genesis on it.

As an architect, I appreciate the human scale of the early Romanesque churches and monasteries much more than the vast grandeur of the Gothic cathedrals, which I find overpowering. One such monastery is the Notre Dame de Sènanque in Provence. The setting which the monks chose, is superb, - with the monastery nestling, as it does, between two low hills and a clear stream bubbling along the valley below. Each of the shapes which form the building, - the apse, the nave and the cloister - arises naturally from the needs of the interior and fit harmoniously together. It is the most simple of buildings and yet says so much about the life of the monks who lived in it and the people who designed it.

Notre Dame de Sénanque, Provence, 12th century.

8.3 Recent History

The Pope of the time was aware of what was happening in Germany during the Second World War. He knew perfectly well that the Jews were suffering in the concentration camps. How was it possible for a man, supposedly appointed by god in order to carry out his purpose for the salvation of all men, not make his concern about the situation crystal clear? Not only did he not condemn the Nazis, but he even seemed to support them. At the moment when I understood the true position, I lost what little regard I had had for the Catholic Church.

The Pope has much power and is not afraid to use it. I need only cite his refusal to allow the use of condoms, (which would reduce the spread of AIDS) and abortions. The Church no longer believes in witches or vampires (who needed to be buried with stakes through their hearts), so they are prepared sometimes to change their minds, but it takes them many hundreds of years.

The Vatican still insists that their priests and nuns remain celibate. This is an unnatural condition for men and women to live their lives and has resulted in the most deplorable situations in children's homes run by the Church. We all have heard of the tales of both the physical and mental abuse, which were endured by children for so long and in many different countries. The church has had to pay millions of dollars in compensation to some congregations, thereby accepting that they were guilty of sinning against children. This is in direct contravention of Christ's wish: "Suffer little children to come unto me." Yet the practice still continues and, until they allow priests to marry, it will continue to do so.

A report dated 20 November 2009 - "The Report of the Commission of Investigation into the Catholic Archdiocese of Dublin" covering the years 1975- 2004, concerned allegations of abuse against forty-six priests in Dublin. It was commissioned by the Irish Minister for Justice and took fifteen years to produce. The Garda (the Irish police) during those years, had been presented with documented evidence concerning the names of the priests involved, yet the only action taken, was for the police to speak to the bishop responsible for the diocese.

Such is the awe of their religion, which is still held in Catholic countries. The result was for the priest to be transferred to another parish, in some cases no doubt, to continue his perversion. Six months before, the Ryan Report also found that Church leaders knew that sexual abuse was "endemic" in boy's institutions.

The archbishop of Ireland has finally been forced to apologise for the fact that he did not inform the police when he knew that a paedophile was in a position of being able to abuse young boys of his church. He has left it to the Pope as to whether he should resign. Any normal person would have resigned immediately. The Pope himself has been accused of exactly the same cover-up from America. How likely is it that any action will be taken on either count? The Vatican appears to act and believe that payment of money will resolve any problem, - a modern equivalent of the sale of indulgences?

Abuse is too polite a word. There is another word, which shall not be used here. One of the complainants, a young man, has written a book about his experiences as an altar boy. He has had the courage to let the world know how

his life had been destroyed by the acts of his priest. His final words were, "Would you trust the Catholic Church after fifty years of lies and deceit?" One might as well say, "after two thousand years". Priests have been abusing their altar boys since time immemorial, no doubt continuing the practice as a result of their own mistreatment. It may well have been considered one of the perks of taking "holy orders". If forty-six priests were involved in a small city like Dublin, the practice must be widespread throughout the rest of the country. It is also not possible for this to have happened only in Ireland. A huge media outcry has arisen of children now known to have been abused at the hands of their priests in nine different countries. Perhaps others will now have the courage to speak out in France, Spain and even Italy itself.

The Catholic Archbishop of Westminster has wholeheartedly apologised for the conduct of some members of the English Catholic Church – though one might say, a little too late and only after it had been exposed to the eyes of the world. These are the people who have claimed to be the representative of god. How is it possible now for us to hold them in any respect whatsoever?

Some married Anglican priests transferred to the Roman Catholic Church, when the problem of homosexual appointments, made by the Archbishop of Canterbury, caused them to leave the Church of England. They were accepted as practising priests and permitted to remain married; - some are obviously considered to be more equal than others. How hypocritical can one get? Now the problem of women priests has raised its head as well. Both religions have been talking together for the last forty years in an apparent effort to amalgamate into one Church. Such talks are doomed to failure. King Henry the

Eighth appointed himself as "Defender of the Faith" and the monarch still retains that title.

Joining together could only mean one thing: that the sheep, who strayed from the fold, has returned at last – an ignominious conclusion which the Anglicans could never accept.

The Archbishop of Canterbury was recently in the Vatican to talk to the Pope, to complain that the Catholic Church is surreptitiously encouraging Anglicans to join them. The Pope maintains that he has only made the means possible to enable them to do so, if they so wish. They are two old men who are going through the motions, only to try to satisfy their adherents that they are doing their best. They have no intention of coming to any agreement, whatever their protestations to the contrary; it is the deaf talking to the deaf.

The Vatican still encourages the belief that the power of a saint's bones is able to bring about an improvement in the physical condition of the afflicted. Lourdes is only one example, where long queues of disabled people form to gain access to the grotto of Sainte Bernadette, (d.1879), in order to be cured. Amongst other things, which I find most regrettable, are the number of memorabilia, which the faithful are persuaded to buy, with money they can ill afford. One other recent example is that of a clear plastic casket, supposedly containing some bones of a young Catholic nun, Sainte Thérèse, which was transported around Britain for the faithful to pass by, touching the casket and crossing themselves. These are perfect examples of pure superstition, a worship of the occult, which is only able to continue with the support of the church. I find it difficult to believe that the hierarchy of the Roman Catholic Church really believes in such stupidities; they are only pandering to the gullibility of their congregations.

Derek G Potter

The Pope has been viewed on TV kneeling in front of the Turin Shroud, recently placed on display after a number of years of being kept hidden. This is a desperate attempt to divert attention away from the trauma, which the church is now undergoing. He knows that the cloth was only discovered by a French knight in 1356, a time of unbridled superstition, when many such objects were fabricated. It was woven in the Mediaeval period, (as proved by three different laboratories using radio-carbon dating procedures in the1980s), was conjured up in the mind of man and is one of the greatest and most successful confidence tricks of all time – the other being religion itself. The present Pope does not accept scientific evidence any more than previous Popes, who dismissed the theories of both Galileo and Darwin without hesitation. Come, Catholic Church. Join in the twenty-first century and give up all such fantasies. There are many people who need a nun's understanding and consolation without those ridiculous notions.

The Pope was on a visit to the Czech Republic, it was said as a missionary. He had been told that they are the least religious people in Europe. This gives me great confidence in the intelligence and sensibility of the Czechs. It is clear that the Pope has no idea of what is going on there and thinks he can help. The people have obviously come to the conclusion that religion is of no assistance to them; they have to solve their problems on their own. I can only wonder how he imagined that his visit would change anything.

The Roman Catholic Church currently maintains its power over some two billion people, mostly in impoverished countries and it demands that they pay dues to the wealthiest church there has ever been. The rite of confirmation of young children must be discontinued. As the Catholic Church has always known, "Give me a child of seven and he is mine for life." It will take a

very long time for this indoctrination to be reversed. Why was it that not one Pope could bring himself to follow the teachings of St. Francis, who gave away his clothes to those he thought were poorer than he? There can only be one answer: all power corrupts and absolute power corrupts absolutely.

If priests believed anything sincerely at all, they clearly have acted as if a confession at the end of their lives would get them into heaven and allow them to perform whatever actions they wish, in the meantime. Do they never ask themselves the question "What would Christ have done?"

There has recently been a debate broadcast on BBC TV, the subject of which was "The Roman Catholic Church is a power for good throughout the world." With an educated audience of two thousand in central London, the motion was heavily defeated by 1800 votes to 300, a ratio of 6 to 1, so perhaps the world is beginning to realise at last the true situation. Another similar debate, this time on American television, The Intelligence Squared programme in October 2010, "That Islam is a power for good", was also defeated. Those speaking on behalf of the motion were faced with great difficulty in finding arguments to promote their cause and fell back on quoting certain passages from the Quran. As with the Bible, alternative verses can always be found, which state the exact opposite.

The net is tightening on all sides: the ground moving beneath their feet. The world holds its breath while waiting for them to collapse.

Chapter 9
Saudi Arabia

9.1 Riyadh

I had the extraordinary experience of working for two years as an architect in an Islamic country with a totally different religion, social customs and government. It was, for example, entirely forbidden for the people who went to work in Saudi Arabia from the West, British and Americans alike, to bring a Bible into the country. To the Saudis, this meant only one thing: that we were trying to bring Christianity to the Arab peoples. The penalty was instant exclusion, being sent back on the next plane. Such an act was regarded as far more serious than bringing in a bottle of Scotch whisky. No churches of any sort were allowed to practise. Sunday was a normal working day with Fridays, being the day for Islam to worship, our only free day.

We were permitted to eat and drink normally, (no alcohol of any sort), during Ramadan, although Muslims were only allowed to eat after dark. The shops were then open all night and we found it quite normal to go shopping at three in the morning. The Saudis demanded that we worked on Christmas day. I say this not in any spirit of complaint, but simply so that we recognise that the differences of religious practices are absolute. Our passports were taken away on

entry and we were not permitted to leave without an exit visa stamped upon them. Social customs were also quite different. It is well-known that women have many restrictions and are still not permitted to drive. This resulted in very young Saudi boys, certainly well before the age when boys in the West are allowed to take the wheel, driving their sisters to school. Some boys were so small they could hardly see over the steering wheel of their enormous Cadillacs. It was usual for the Saudis to leave a meeting with no explanation, kneel down for their prayers in a corner and after a short while rejoin the meeting. I had no problems with their conduct and accepted that this was a natural thing for them to do.

I refused to go out to Riyadh unless my wife could come with me. The firm I was working for at that time, had had so many difficulties with wives of their staff in such a completely different restrictive environment and anti-social conditions, that they had decided that no wives would in future be allowed to go there. However, I, with my wife, being older than the younger architects and engineers, who were the normal volunteers, were finally accepted. She had a much more interesting experience in the country than I did and thoroughly enjoyed it.

I was immersed in the daily problems of the site and its construction. Our firm was involved with the development of the completely new diplomatic area, which was being relocated from Jeddah on the Red Sea; the king having decided unilaterally that he wanted the diplomats nearer to hand.

This huge area, (part of the virgin desert), was sealed off from the rest of Riyadh and it was permitted for the wives of diplomats to drive there, but never outside the gates. Our

design was for the sports centre, providing a sports club, squash and tennis courts with a huge outdoor swimming pool, the largest in the world -(everything in Saudi has to be the largest in the world). When the buildings were completed, superbly constructed by the South Korean contractors, we finally laid a grass lawn and planted many trees, all with an automatic water supply. I designed a large aviary in one of the courtyards with a fountain inside for the birds. I am very pleased to remember that I was part of a team, which made the desert bloom.

The contractors were young men from South Korea, drafted in by their government to learn, by direct experience, the methods which Europeans used in modern construction. They were driven very hard by their managers, all of whom spoke excellent English. One evening we arranged a badminton match between us and my wife was asked to participate. Being perfect gentlemen, they allowed her to win.

9.2 The Princess

My wife met a Saudi princess, who lived next door to our villa. Here it must be explained that most of the senior echelon of Saudi society were princes or princesses of one sort or another, the result of the first king of Saudi Arabia, King Saud (hence the name of the country) having married so many wives quite deliberately, in order to have many, many children. In this way he sought to control the nation. All his progeny would naturally become part of the government of the country. There could never be any opposition to his rule as a result, nor any likelihood of democracy.

Both our neighbour and her daughters had been educated in Switzerland and were no different in social awareness and education than my own daughter, from a good school in England. Her two young sons used to come into our compound for a swim, so we were completely accepted as friends and of a similar social standing.

I believe the princess used the excuse that she wished to talk with my wife in order to perfect her use of English. I spoke to her on rare occasions, but her English was perfect, not only in usage, but also in pronunciation. My wife was invited to parties in the desert with the princess' friends. She even attended an unusual family wedding, where only women were present, except for the bridegroom. Jean told me that the dancers were Egyptian women with candles on their heads, reminiscent of the Arabian nights. She even went with her, on one occasion, to the king's main palace in Riyadh without any head covering. Of course, I was not invited to any of these ceremonies.

I did meet the lady when I, as a professional, could be spoken to without the presence of her husband. She asked me to design a fountain for her garden. I remember that she was permitted to pay me money when the contract was completed; it was not necessary for her husband to do this. Not even my wife ever spoke to him; she sometimes saw him in the house, but he would sweep past without pausing to be introduced: such a different way of life. I found it fascinating, – not that I wished to live as they did.

The women of Saudi are believed by the West to be subjugated to their husbands' will. That was not my experience. They are in complete control of the household (including the daughters, but not the sons) and they not only can, but must,

Derek G Potter

take all decisions as to how it should be run. Outside of the home, it is a very different matter. Whenever we walked down the street, there were always religious police around. Should they decide that a woman was improperly dressed, they would strike the man sharply on his ankle with a long cane. It was his responsibility to ensure his wife behaved with proper decorum. It was of course, strictly forbidden to walk together with a woman who was not your wife, or even to drive one alone in your car. It was for this reason that my wife and I were in great demand. Together every Friday, our day of rest, we would drive to the main hospital and collect Irish nurses and take them to the compound for a barbecue. It was the only way the girls could leave the hospital and for our engineers to have female company after a long week. There were no cinemas, no theatres and no bars where one could go for a talk with friends. Everybody had to discover for themselves, how to relax.

We lived in a compound surrounded by high walls, where we were in reasonable security, although the police had the right to enter without notice at any time. All the ingredients to make wine, even gin, were sold in the shops complete with recipes. They were described as grape juice. They tasted dreadful, but we all had to participate to entertain chaps from other compounds. We found that if you put enough orange juice in the gin, it was not so bad.

Jean arriving in Riyadh

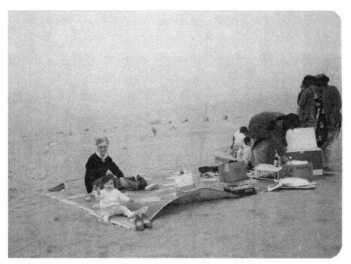

In the desert

My wife always wore a long dress down to her ankles and a gown to cover her arms, but she was allowed to leave her hair exposed. Trousers were only permitted for women from Pakistan. We bought some cloth on one occasion and took it an Indian tailor to be made up. The tailor's shop was a hole in the wall, with no glass in the windows and no door. Neither I, nor my wife, needed to enter. The tailor was not permitted to touch my wife to measure her. He decided what the frock should look like (I had drawn a sketch of what we had agreed) and judged her size by eye. The final result was perfect.

Whenever we boarded a plane, the young Saudi girls, having entered fully covered up including burkas, would disappear into the toilets and emerge in the most up-to-date, glamorous, French-designed costumes with perfect make-up. They were, of course, extremely well off. I say this in no condemnation of any sort, - they were in no sense

being hypocritical. They were only behaving naturally as young girls do, having to conform to their social customs when in the country. That is how people everywhere behave, whatever their religion or their social class.

Women in the West find it impossible to understand how these Saudi women allow themselves to be under such control within their society – until they remember that, not so long ago, they themselves had no freedom either. Throughout the nineteenth century, women in Europe had no vote, were regarded as the property of their husbands and not allowed to own anything. The Roman Catholic Church still considers women as second-class citizens, with no say in how the church is organised. They have issued a decree that the very idea that women should be able to become priests is to be considered a mortal sin. Women are also hugely under-represented in politics in democratic societies. Are there not many men, even in the West, who act as if women are of no account?

There was another, most unpleasant side to Saudi life which took place in a central square in the oldest part of Riyadh, where we were warned never to go on Fridays. We called it "Chop Square", for obvious reasons. That was where physical punishments were carried out in public, including executions. If foreigners were seen to be present, they were pushed forward in order for them fully to appreciate Saudi law and justice. As a result, there were almost no thefts and it was unnecessary to lock one's car. I would have preferred, however, to live in a country with a lot more theft, rather than one in which such barbaric, mediaeval punishments were the norm.

I used to go down to this square to cash my cheque every week. There were many other banks, all just the same as any other modern bank in the Western world, but this one was different. It was a long, narrow room with a wooden counter stretching the length of the room. On the other side were several cashiers. One had to get one's cheque countersigned by two senior members of the bank first. Then one approached the counter, whereupon the cashier reached behind him and opened a cupboard, reaching from floor to ceiling, full of banknotes from every country in the world. There was no plate glass screen, no security whatsoever. It was normal for them to accept the transaction with absolute trust on both sides. One could have reached across without difficulty and helped oneself.

Some of the English and American newspapers were on sale, several days late, as they had been heavily censored with huge areas blacked out by thick ink pens. A large number of people must have been employed by the Saudi government just to do that. It was not only pretty girls who caused them anguish, but any reference to Israel whatsoever.

When I left in 1985, I believed that the entire Saudi society and its social customs, even its religion, would collapse within ten years. The modern world, with instant communications, would produce the necessary revolutionary changes in their society. How wrong can one get? It has hardly changed one iota since I was there.

Chapter 10
The Intolerant Society and Slavery

There have been too many examples of man's intolerance towards his fellow man throughout history, only a small number of which have been mentioned in this book, but the greatest of them all, was slavery. The use of slaves largely died out following the downfall of the Roman Empire, except in Africa and the Middle East. During the eighteenth century, however, it was readopted and systematically used by several European nations, (most notably - Great Britain) and the United States. Slavery was at its height when both nations were at the forefront of the development of democracy and were also strongly religious, supposedly following the Christian ideal.

This new slave trade was the result of two situations coming together: the need for large numbers of workers in the colonies of America and the West Indies - and African tribal leaders who wished to get rich from European traders. The transfer of slaves from the west African coast to the West Indies to work on sugar plantations, was a major contribution to the immense economic power of England. It culminated in the formation of the British Empire and made the fortunes of many people, who believed they were good Christians and upright citizens. It is undeniable that it also allowed the United States to develop more rapidly than would otherwise have been possible. In their case, it was the cotton grown in the southern states, which led to the demand for slave

labour and produced a huge financial return for the south. It is unlikely that their American descendants appreciate that fact.

William Wilberforce (1759-1833) was one man who stood against slavery for his whole life. He became an evangelist and entered the British Parliament with the sole intention of getting a law passed to abolish it.

Wilberforce received little support from any government and none from the Archbishop of Canterbury - nor from those forty bishops in the House of Lords, any one of whom could have produced such a bill, had they considered it to be their Christian duty. As a part of his plan to persuade the MPs to vote against slavery, Wilberforce produced a model of a slaver, the ships which transported thousands upon thousands of slaves across the Atlantic. Many died en route and were thrown overboard every morning.

By removing the top deck of the model, the appalling conditions in which African men, women and children were imprisoned, were finally revealed and convinced MPs, on both sides of the House, that they must abolish that ghastly practice.

Wilberforce received the news that the Slavery Abolition Act had finally passed into law on his deathbed, three days before he died in 1833. Yet again, such a move towards human understanding and compassion towards those less fortunate than oneself was only brought about by a majority of Parliamentarians standing against the power of both church and state, after the superhuman efforts by one man throughout his life.

Slavery in America continued until the outbreak of the Civil War in 1861. Eleven southern states (known as the Confederacy) seceded from the Union when they believed that slavery would be abolished in their states, as it had already been in the North. The President, Abraham Lincoln, vainly tried to hold the Union together, but finally had to accept that war was inevitable, - the two sides were irrevocably opposed to each other. There were three and a half million slaves listed in the census taken in 1860 and the whole of the south's economic success depended upon them gathering the cotton, which sold for high prices in Europe. The invention of the cotton gin vastly increased the manufacturing capability of the mills in the north of England and the price of raw cotton soared.

The war lasted for four years, during which six hundred and twenty thousand men on both sides were killed, with uncounted numbers seriously wounded. A civil war is the worst example of all, with brother fighting against brother, - father against son. It has been estimated that thirty per cent of the male population of fighting age on the Confederacy side were killed, with the corresponding figure of ten per cent on that of the Union. Having the largest population and with ninety per cent of the factories manufacturing weapons, it was inevitable that the North was ultimately victorious. The final abolition of slavery throughout the United States was contained in the Thirteenth Amendment dated 1865.

Chapter 11
Tolerance

11.1 Mankind Created God

I have known many people in my lifetime; the vast majority were good people, intelligent, kind to their children, concerned about the condition of those less fortunate than themselves and the world situation. This is their natural condition – they do not behave like this because of their religious beliefs. I discovered the same response from the Arabic people I came to know in Saudi Arabia, with a quite different religion, social conditions and even without democracy. They would all be exactly the same people without the so-called comfort of religion.

I have been a closet atheist since reading *Leaves from the Golden Bough* by Lady Frazer over sixty years ago, when I was eighteen. (T. S. Eliot referred to *The Golden Bough* in his poem "The Waste Land", which I had read at that time). Her husband, Sir James Frazer's original work of some twelve volumes, were too many for easy assimilation by a young man. When Victorian gentlemen researched a project, they did a thorough job. In this vast work – which has not been attempted before or since, as far as I know – Frazer recorded all the ancient beliefs of mankind, which he could discover.

Frazer concentrated upon their idea of "magic" being able to control the world around them, change the weather, make crops grow, ensure the fertility of women and the success of the hunt. Almost always there was one man in the tribe who was regarded as the person who could bring these desirable things about. It is astonishing to realise the degree of complexity of the ceremonies, which men devised at this remote period. The same ideas were concurrent throughout Africa, Australia and Northern Europe. Some of their beliefs and superstitions were still held at the turn of the twentieth century, in remote corners of the globe and even in the mainstream religions. All these stories, over time, became transmuted into the idea of what a god would be like, who was powerful enough to create the world.

Naturally, although they came from men in completely different locations and at different times during the world's development, they all had common experiences in their lives and therefore had ideas with substantially the same characteristics.

1. Each tribe had had different ancestors and therefore held different ideas about their gods.

2. Every member of the tribe was taught about god from an early age and had to understand and accept that their particular god held total authority over the tribe. The displeasure of the god, caused by any one member, would affect all the others.

3. No one was permitted to move to a different tribe to learn about another god.

4. Only certain privileged members of the tribe were allowed to communicate with their god. They were then uniquely able to tell the others what their god wished to happen and how to behave – a position of great authority, which men have always sought.

5. The god had to be worshiped communally and individually.

An all-powerful, all-seeing, invisible father figure, whose word was not able to be questioned, was the perfect way to keep disagreements under control and bind the tribe together. This was one fact, perhaps, which helped to ensure the survival of a species, who was neither as strong nor as fast on his feet, as other animals. Man was just more intelligent, realising that he needed both to live in a group and to have an outside force for security.

The desire to be worshipped is an entirely human characteristic. The ancients transposed that belief into the idea that their god would be more likely to respond to their requests if they acknowledged his greatness. A god who could create the tiger (surely one of the most perfect of species), the Milky Way, the immensity of the entire universe, to say nothing of mankind himself, would have no need of worship. But human beings like to think he did.

Einstein was not a theist. He was apparently a pantheist, as was Spinoza, whose philosophy he admired. *"I believe in Spinoza's god who reveals himself in the orderly harmony of what exists, not in a god who concerns himself with the fates and actions of human beings."*

Nehru also said, at much the same time: *"The spectacle of organised religion in India and else-where, has filled me with horror and I have frequently condemned it and wish to make a clean sweep of it. Almost always, it seemed to stand for blind belief and reaction, dogma and bigotry, superstition, exploitation and the preservation of vested interests."*

I could not agree more.

11.2 Omar Khayyam

The verses of *The Rubaiyat of Omar Khayyam* show that "The Joy of Life" was accepted by educated Persians in the twelfth century as an ideal, - less than one hundred years after the Norman invasion of England. Those that I have chosen to quote are a fraction of the entire collection, but they seem to me to illustrate his view of how life should be lived by everyone.

A loaf of bread, a flask of wine,
A book of verse beneath the bough
And thou, beside me, singing in the wilderness
Ah! Wilderness were Paradise, e'now.

Myself when young, did eagerly frequent
Doctor and saint and heard great argument
About it and about but evermore, came out
By that same door as in I went.

I sent my soul through the Invisible
Some letter of that Afterlife to spell
And after many days my soul return'd
And said "Behold, Myself am Heav'n and Hell.

Heav'n but the vision of fulfill'd Desire
And Hell the Shadow of a Soul on fire,
Cast on the Darkness into which Ourselves,
So late emerg'd from, shall so soon expire.

The moving finger writes
And having writ, moves on
Nor all thy piety nor wit
Can lure it back to cancel half a line
Nor all thy tears wash out a word of it.

Omar Khayyam was the greatest astronomer and mathematician of the Middle Ages. He precisely calculated the length of the year, produced quadratic equations and attempted to solve cubic equations, which have still not yet been achieved. In addition, he was a poetic genius, writing the most simple and yet profound lines on the human condition. In none of them did he ever suggest a religious faith of any description; he concentrated on the true and enduring pleasures of life - and its short duration.

His philosophy, so perfectly translated by the Victorian poet Edward Fitzgerald, has been admired ever since. A sculptured head of Fitzgerald has recently been unveiled in the town nearest to where Omar Khayyam was born – most exceptional, considering that Moslems never normally allow the portraiture of the human figure.

Khayyam knew all that time ago, even though he had been brought up under the Islamic culture - and was also well aware of Christianity, - that we alone are responsible for our lives, for our world and for all of our fellow human beings. That there is no one else to blame for the way we live, for how we treat our neighbours, or our planet. He

told everyone through his writing that there was no heaven and no hell to come in the afterlife. Perhaps all those of the Moslem faith will learn to follow his example.

11.3 Revolution

There were three revolutions in the late eighteenth century, which bear out my statement at the beginning of this book, that similar things happen in different parts of the world at almost the same point in time. Men's minds seem so closely attuned to one another across the globe, that they result in actions, which show that, at certain times, there is a massive movement of mankind towards one particular goal.

In 1776 the American Revolution started in Boston, Massachusetts, when the American settlers in the thirteen colonies decided that they could no longer accept being governed by a foreign power, Great Britain. Their rallying cry was, "No taxation without representation." A remarkably few people, with even fewer armaments managed, through their dedicated zeal, to defeat the might and power of Great Britain.

This resulted in the American Declaration of Independence, which included these words, that have gone ringing down the centuries ever since:

> *We hold these truths to be self-evident, that all men are created equal, that they are endowed by their creator with certain inalienable rights, that among these are Life, Liberty and the Pursuit of Happiness. That to secure these rights, Governments are instituted among*

> *men, deriving their just power from the consent of the governed.*

The idea that the "pursuit of happiness" was one of the rights of mankind, is truly revolutionary. It is the only time in history that such words have been uttered. The Declaration is certainly the most potent and consequential statement, not only in American history, but also of the Western world. It has come to represent the moral standard by which the United States and all democratic governments should be judged. It also had an extraordinary effect throughout Western countries, especially in France and Great Britain.

We now know that Thomas Jefferson, one of the signatures, kept several hundred slaves on his plantations, a fact which was pointed out by the English freedom lover, Jeremy Bentham. This only shows the frailty of men everywhere, - it does not reduce the power of those words. Benjamin Franklin, who signed the document at the age of seventy, said memorably, *"Yes, we must all hang together or, most assuredly, we shall all hang separately."*

The Declaration also claimed the right of revolution against an unjust government. It is unsurprising that France took up the challenge only a few years later. In1789, the French Revolution started when the proletariat, having broken into the notorious prison, the Bastille in Paris, freed the few prisoners who remained. This action, following on so quickly from the revolt in America, changed the face of government as the world understood it. The revolution overcame French rule by the aristocracy and the king, who both had totally autocratic powers of life and death over their subjects. For a short while, the government changed into a democracy, – but as one of the worst examples there has ever been. There were

many deaths of the aristocracy on the guillotine during the so-called terror, until Napoleon was appointed to govern by martial law. It was always thus: autocratic rule degenerates into anarchy. This is the only way that people, with no ability to call their government to account, have been able to change their situation; it is the natural order of events. Governments, however dictatorial, cannot be changed by outside force. This is my understanding of the problems the world now faces in the Middle East. Only people within their own country have, in the past, been able to decide their future for themselves and demand change - and that remains true today.

Liberté, Egalitè, Fraternitè, the motto of the French Republic, follows on naturally from the Declaration of Independence, much more direct, simpler and entirely unambiguous, even though the words are not a statement, but an aspiration. In their attempt to achieve freedom from a moribund and outdated government, the French people were supported by the United States of America.

They showed their gratitude by sending the Statue of Liberty, which now stands at the entrance to the port of New York, with the inscription, - *Give me your poor and dispossessed, your huddled masses, yearning to breathe free.* Those huddled masses yearning to breathe free, are still there around the world, two hundred and thirty-five years later. They yearn for freedom from want, freedom from fear and freedom from oppressive governments.

Since the opening of the twentieth century, America has been the most advanced nation state in the world. In particular, the United States has led the world in economic and industrial advances – but regrettably, not always in recognising the universality of man. Such thinking has only recently started

to be accepted. Without doubt, this was due in part to the depth of religious zeal which the founding fathers brought with them and which still remains. That was, after all, their reason for leaving England. No president has, as yet, been elected who did not subscribe to the Christian religion. Even Great Britain elected a Jewish prime minister, Disraeli, in the nineteenth century. It is surprising that the most advanced country in the world in many disciplines, should have been so late in recognising that the adherence by their representatives to a strict, conformist religion will lead nowhere.

In the late 1700s, a quiet revolution started in England, known as the Industrial Revolution. This was the age of an immense change in manufacturing procedures and the use of power generated by steam. Great Britain started down the road of industrialisation and became the predominant world power of the nineteenth century as a result. They also invented the steam engine, which transformed methods of transportation. All these dramatic changes to the way of life, which had remained largely the same for many years, brought about a better understanding of the world by the intelligentsia of Europe. It was called the Age of Reason, which was immediately followed by the Age of Enlightenment.

Jean Jacques Rousseau in Switzerland wrote the *Social Contract,* in which he claimed that "Natural Man is inherently virtuous". England followed suit and, for a time, religion amongst the middle classes practically disappeared. The study of nature, the new religion, took its place. Some of the most marvellous painters and poets which England has ever produced, appeared at this time: Turner, Constable, Byron, Wordsworth and others. They captured the spirit of this age as Shakespeare had done before.

Chapter 12

The Twentieth Century

This century produced extraordinary advances in so many ways. Early in the 1900s, the flying machine was invented, improving transportation across the world, as the railway had done the previous century. Before the end of the century, a rocket had carried men to the moon - and computers, the Internet and international communication, television, mobile phones, had been developed, – all to have a profound impact on the way people live their lives today.

12.1 Women and Democracy

Young women nowadays, emancipated as they are, find it difficult to realise how late female suffrage has been established. My mother did not get the vote until 1928 when she was thirty. I am proud that Great Britain was among the first nations so to do, terrified though the elder statesmen were at the prospect of being replaced by a monstrous regiment of women.

Those suffragettes were great women, certain of what they wanted, deserved - and completely fearless. The movement in 1908, was led by Emmeline Pankhurst, who was not averse to practising some degree of violence. She realised, that passive resistance would never bring about the changes

of men's thinking, which were necessary to achieve the franchise. She and her daughter Christabel, interrupted many political meetings, attacked Churches (the Church of England was against giving women the vote) and chained themselves to the railings of Buckingham Palace, as the monarchy was also against their emancipation. They broke windows in Downing Street and set fire to post boxes. One, Emily Davison, locked herself in a cupboard within the House of Commons on the day that a census was held. This required everyone to give their address on the day in question and it was the only time that a woman was able to do that legally. Later, she was courageous enough to throw herself beneath the hooves of the King's horse during the Derby in 1913 and was killed, - the first suffragette martyr. Her statue stands in the entrance lobby to the House of Commons, so she is now permanently in residence.

It could not have been easy for young, middle class (and even upper class) women to stand out against the male members of the establishment (many times, even their husbands) and be prepared to accept that most cruel form of torture, forced feeding.

It is impossible to comprehend how this could have been administered by the medical profession; one would have thought that this was against their Hippocratic oath.

The Great War in 1914, when so many men were called to the colours, brought about the desperate need for women to replace them in the factories. Following the Armistice, there was no way that men could prevent them from continuing working on their own account and this resulted in their final freedom.

Hopefully a new form of democracy will arrive and be accepted throughout the world for future peace and prosperity. It must contain at least 50 per cent of the female sex. Such an enlargement of the franchise and feminine representation will reduce the possibility of war between nations to the minimum.

12.2 The United Kingdom

The Norman conquest of England in 1066 laid strong foundations, which have lasted to the present day. Within twenty years, William had instituted a complete record of the land, its owners and livestock called the Domesday Book. Fifty thousand people were called to give evidence, an astonishing achievement at that time. The Normans spoke French, while the English spoke Anglo-Saxon. Within a short period, French, being the language of the victors, predominated. Eventually they amalgamated to become the English of Chaucer.

England initiated the concept of a modern democracy; the House of Commons is known as the "Mother of Parliaments". The historical greatness of Great Britain is undeniable, but is now in the past. The traditions of the state are very often taken as our raison d'être, but we must now learn to think of the future. The fact that there are some forty bishops in the Church of England who are automatically given seats in the House of Lords by right, is a clear anachronism and must be withdrawn. At the time when parliament was first formed, those called to the church were highly educated and it made sense that they were so appointed. That is no longer the case. Religion was held then to be the bedrock of

society. They might even hold the king in check, as indeed they sometimes did. But we now live in vastly different circumstances.

The British have been fortunate in that the monarchs, during the last 150 years, have largely been nonentities – apart, that is, from the female of the species, Victoria and Elizabeth. They both clearly understood their position and acted intelligently within it.

Queen Victoria is believed on only one occasion, to have criticised her Prime Minister, Gladstone, when she maintained that he always addressed her as if he were at a public meeting. Since her days, there has been a consistent decline in the ability of the heads of state.

Edward VII, her son, wished only to enjoy the favours of many women, especially French. Such liaisons admittedly formed the basis of the Entente Cordiale, which proved to be of profound importance during both world wars. But is that how diplomacy should proceed? George V, his son, did nothing of any importance, but at least he did not interfere too much. Edward VIII followed in the steps of his grandfather and was forced to abdicate when he wished to marry an American, who had been divorced. George VI was king during the Second World War and had great difficulty in conducting himself, let alone acting as head of the state. It was fortunate that Churchill was Prime Minister at the time – and that the King was also possessed of a sterling wife, who became virtual queen in her own right. Now we have her daughter, who has carried on the tradition of Victoria magnificently, rarely putting her foot in the wrong.

Royalty presents honours to people who have distinguished themselves, thereby benefitting the state. The choice of people

selected for honours nowadays is curious and populist. Sir Alexander Fleming, the discoverer of penicillin, which has saved so many lives throughout the world, was not chosen. The Queen's grandfather, George V, initiated the honours system in the name of the British Empire and it continues to this day. In 1947, India was granted Independence, which was, in effect, the end of the British Empire. Six years later the Queen ascended to the throne. What a marvellous opportunity was missed to create a new form of honours, perhaps in the name of the Commonwealth. But no, - we have to continue with commemorating past traditions and prefer to live in a different age from any other nation, rather than the present.

Such traditions as, for example, - the Royal Opening of Parliament, by a person who has not been elected and has no power. Even Victoria decided that she was not going to be placed in such an ignominious position. Edward VII, who loved the panoply of state, reinstituted the event.

Great Britain has never had a written constitution, preferring to follow the path along which it started, – by making it up in Parliament as it went along. This resulted in the power of the monarch wholly being transferred to the government over time, with the head of state being on ceremonial duty only.

12.3 Charles, Prince of Wales

My mother, being keen on the theatre where my father was not, used to take me to various West End shows. One evening in 1948, at the end of the performance, the manager

of the theatre announced that Princess Elizabeth had been delivered of a son.

The whole audience walked down the Mall, - the only time I have done so, -joining an enormous crowd outside the Palace, singing and enjoying the occasion.

Charles, now an adult prince, is an entirely different proposition from his progenitors. It is my belief that the Queen would have appointed him as King, had she believed that he would have been capable of carrying on the responsibility with a proper understanding of his position. Clearly, she is sure he cannot.

Charles lost any feeling of respect from the architectural fraternity, by ensuring that two projects, - both won by highly qualified architects following a worldwide competition, - were effectively cancelled by him. They were a new redevelopment adjoining St. Paul's by Arup Associates and the extension to the National Gallery by Norman Foster. This was described as "a monstrous carbuncle on the face of a much loved friend" by the Prince, in a lecture to the Royal Institute of British Architects. He is not only unqualified, but also without taste or discretion. How was it possible that he thought he could talk to that august body in such a manner, except in the arrogance of his unelected position? Now he has brought about the cancellation of the redevelopment of the Chelsea Barrack's site, which was designed by Richard Rogers, an architect of world renown. Charles effected this by going behind the backs of all properly elected authorities and persuading an Arab prince to drop the planning application without any justification. The Prince never seems to recognise any solution other than

his own. In this respect, he appears to be akin to a religious fanatic.

We should remember that it was Queen Victoria's husband, Albert, a German prince, who challenged the reactionary thinking of the time. He advocated new advances in many fields, especially architecture and promoted that most modern of buildings, the Crystal Palace, built for the great Exhibition of 1851. He was a far cry from those who live in the royal enclave nowadays.

The architectural principles of good design are as applicable today, as they were when they were first laid down in the eighteenth century. They are the reason for the failure of the town of Poundbury, constructed by Prince Charles and his architect Leon Krier. It was based upon a desire to recreate the past, in this case the superb Cotswold villages.

Beautiful they undoubtedly are, but it is quite impossible to recreate the times in which they were built. Such an attempt resulted in a toy town and devalued the original concept; it does not enhance or discover anything new. Charles should have learned from his initial attempt to "improve" his country mansion, a good and perfectly respectable example of English architecture of its period. Apparently, it was not considered grand enough for the Prince, so he added out-of-scale columns, with an incongruous pediment perched above the main entrance, thereby effectively destroying the building's inherent dignity.

Everyone, including the Prince, has the right to express an opinion on any subject and campaign against proposals to which one objects. But those examples I have cited were all a flagrant misuse of power, wholly out of place for a future monarch in a democratic society. He is also behaving in

an extraordinary manner towards the Church of England. He gave a lecture in the Mosque in Regents Park (one from which various terrorists have emerged), apparently believing that Islam is on an equal status to the Church he has sworn to uphold and which he will lead.

Is it not possible that he will continue to decide for himself, guided by a collection of self-appointed nonentities, what actions will be of benefit for the future of the country? No doubt at all that the Queen feels the same, thank goodness. She remembers that there are recent examples of persons in authority in other countries, who decided unilaterally that composers, artists and architects must conform to their ideas. All progress in the arts immediately died. Perhaps the only hope is, that he will behave so outrageously when finally he is crowned, that the move towards Republicanism will gather momentum and he will follow his predecessor, that of the other Charles.

12.4 The Powerlessness of Prayer

On 31 May 1911, in the Harland and Wolff dockyard in Belfast, a ship was launched with the customary prayer, "May God bless her and all who sail in her." Just before saying those words, the lady who pressed the button had said, "I name this ship *Titanic*." One wonders what thoughts went through her mind when she heard the news that the largest ship ever built had sank on her maiden voyage, taking a large number of the passengers and the majority of the crew, including the captain, down with her. Had god nodded off? Or had she said or done something to which god had taken amiss, so that he decided not to bother to

grant her prayer? At the very least, she must have questioned its value. I do not suppose she ever agreed to participate in another launching.

We must rid ourselves of the fallacy that prayer can change anything. The Muslim religion must also abandon its belief that all things are already ordained – that their God alone has decided what will happen.

A brief look at the history of the world surely shows that we have freedom of will and that we have amply demonstrated our ability to use it, for both good and, regrettably, ill. We must use our experience and intelligence to see the world for what it is. Man alone has wrought all the incredible changes, which have come about since we first became a distinct species from other mammals.

12.5 War and Aggression

Early in the nineteenth century, the British Empire strode like a colossus over the rest of the world. Schoolchildren looked at their atlas and saw that a large part of it was coloured red – that which was controlled, in some way, by the Foreign Office. The British gaily sang, "Britons never, never will be slaves" but were not too concerned that a great many other people were. Elgar wrote "Land of Hope and Glory, Mother of the Free, God, Who Made Us Mighty, Make Us Mightier Yet", which is still sung at the last night of the Proms. It was not god who made Great Britain mighty, but the British sailor, who was prepared to sail anywhere for the start of world trade. It was the British soldier who was similarly prepared to fight – and the slave

trade producing vast financial returns. They brought about the British Empire.

The Kaiser in Germany was jealous of his British cousin, the Emperor King George V and believed that the power and prestige of Great Britain should rightfully be German. He also felt that Germany was over-constricted by another cousin, the Czar, on the throne of Russia. Queen Victoria, being the grandmother of most of the royal families in Europe, had hoped that those family connections, which her dynasty had created, would prevent another disastrous war from breaking out. She was to be sadly disappointed. That was not the way that the world worked any more.

In August 1914, the world went to war to discover which nation would be supreme in Europe. The Germans, French, British, Russians and Belgians were all officially committed Christians. They each had many priests and clergymen of all denominations, who religiously held services and prayed for their side to be triumphant. I do not suppose that the troops took much heart from these; certainly the British were extremely sceptical of anything their officers told them – they had had good reason to be so and took no delight in killing the opposition. They knew all too well that they were likely to follow.

Christmas 1914 was a most extraordinary day. The German troops in one part of the battle line, which stretched from the English Channel to Switzerland, started singing hymns. Not a shot was fired. The British soldiers responded by getting out of the trenches and drinking to the health of the Germans in No Man's Land. The Germans likewise followed suit – much to the chagrin of officers on both sides, who never allowed such a happening to occur again. What

a marvellous display of mankind responding with human understanding, one to the other – but how rare and how fleeting.

1 July 1916 saw the great offensive battle of the Somme in northern France. One British lieutenant, believing in the story put out by his commanding officer that there would be no Germans left alive in their trenches, went over the top by kicking a football. The greatest bombardment ever known was thought to have pounded the German lines to oblivion; on that one day there were sixty thousand casualties on the allied side alone. Nation states, their generals and all religious authorities have much to answer for. General Haig, who was responsible for the battle of the Somme, is recorded as having prayed, "God grant me victory before the Americans arrive." One has difficulty in visualising any god of love who would respond to such a prayer.

The charities: Medeçins sans Frontières, the Red Cross, Save the Children Fund and many others, are marvellous acts of kindness and concern for one's fellow man of whatever nationality or religion. They were solely the creation of men, with no hint of religious fervour or nation state involvement. On the other side, we must agree that the holocaust was not brought about by god, but by the arrogance of man. The twentieth century seems to me to have been particularly full of examples of man's inhumanity to man, but no doubt previous centuries would have proved much the same to one living at that time. I cite only the most obvious examples.

The South African War of 1900

The British coined the words "concentration camp". They incarcerated many Boer men, women and their children for no apparent reason. An uncounted number died.

Derek G Potter

Turkey and Armenia, 1910

This was the first example of "ethnic cleansing" in the century. It was not to be the last. The Armenian population was decimated.

Germany and the Jews, 1933–45

Six million Jews and many others died in the Nazi concentration camps; this was defined by Hitler as "The Final Solution". In my opinion, the world war, which followed, was entirely justified – the only one in the list I have given. I am sorry to have to say that Great Britain did not declare war to save the Jews, although their treatment must have been known to the British government for some time before. It was a culmination of the many betrayals of agreements signed by Hitler between sovereign states.

The Spanish Civil War, 1936–38

Following the democratic election of the socialist party, the Spanish army revolted under General Franco. He fought against a militia of people who believed in democracy and were drawn from many different countries. Large numbers died on both sides, including many from the civilian population. The Roman Catholic Church supported General Franco during the war and also when he won and became dictator of Spain from 1938 to 1975. When church and state feel threatened, they will always join together to overcome a common enemy. Both Hitler and Mussolini supported Franco and German aircraft bombed Spanish cities, causing much destruction. The picture painted by Picasso recording the event when the town of Guernica was destroyed, is widely regarded as the definitive record of the horrors of

modern war. A copy is on display in the entrance to the United Nations Assembly building in New York.

The Katyn Massacre, 1940

Twenty-two thousand Polish officers were put to death by Soviet secret police on Stalin's orders and were buried in Katyn Forest, close to the Russian border. For years the Russian government maintained that it had been German troops who had carried out this slaughter. Seventy years later, President Putin finally acknowledged that it had been Russians troops who had done the dreadful deed. A service of commemoration was arranged to be held, with senior members of both governments in attendance.

The President of Poland was killed in the plane carrying both him and his wife, together with Polish representatives, when it crashed en route. The butterfly effect of geography was translated into that of history, with one tragedy leading inevitably to another, down the river of time.

The Partition of India, 1947

Britain granted independence to India, who only agreed to accept it if the whole country were divided into two parts, Hindu India and Moslem Pakistan, - much against the wishes of the leaders, Gandhi and Nehru, who were both pacifists. Many people were killed in the riots and upheavals which followed, when Moslems in India decided to flee to Pakistan and Hindus, in the future Pakistan, to India. At the time when Great Britain was in control, we never found the way to avoid civil war between them, except by force alone. The two governments, which followed the separation, still remain at an impasse sixty years later.

It must solely be religion, which divides them.

12.6 The Solution

To believe that war was the only answer to a nation's problem has been the way all countries have acted for many thousands of years. It is about time that we should realise - it solves nothing. George W. Bush, a born-again Christian and the most religious of presidents, vainly tried to force the Arabic nations into his way of thinking. Not to bring them into the "light" of Christianity, but certainly to start them on the road towards democracy. This may be a noble ideal, but now, even he realises that it cannot be achieved by war. I wonder whether an atheistic president would be likely to try another course.

The ghastly waste of time and love, spent on war, which young men and women can never have again, must come to an end. My sister, Denise, lost her husband, who was shot down over Berlin when she was expecting their first daughter. Omar Khayyam would have been devastated to realise that so little had been learned in the nine centuries since he had written about the love of life.

There are three possible answers as to why war and the killing of large numbers of people, even of their own kind, was regarded as the only solution: Patriotism, Religious Fervour and Xenophobia.

Chapter 13

The Reasons for War

13.1 Patriotism

In the north-east of Trafalgar Square, between the National Portrait Gallery and St. Martin in the Fields, stands a statue, one of remarkably few women in London, superbly carved in white Carrara marble in the style of the time, the 1920s. Her name, Edith Cavell, was little known at her death in 1915.

An Englishwoman, she had been a nurse in a hospital in Brussels at the outbreak of the First World War and remained there after the German army had taken the town. Her only concern was to use her nursing ability for men who had been wounded, be they English, German, Belgian or any other nationality. She believed that part of the help she could give to the soldiers in her charge was to talk to them. They were in a country whose language they did not speak and whose customs were very different from those they were used to. They were also mostly extremely young.

It happened that one of the Englishmen escaped from the hospital and, the Germans alleged, both that nurse Cavell had connived at his escape and, much worse, that she was a British spy. The German High Command tried her, found

her guilty and sentenced her to death. The execution was carried out almost immediately by firing squad. When she was being taken out to her death at break of day, she said the following words, which are carved into the base of her statue: *Patriotism is not enough.* What remarkable words to choose at the time of her death. She has remained a great heroine of mine ever since I first saw her statue.

The Edwardian period in Britain (1901–1912, after the magnificence of Queen Victoria's reign) was a time of unthinking patriotism. Elgar, in the undoubtedly great works of his time, most of which were in a patriotic vein, proved to be extremely popular and came to symbolise the period. A similar situation was felt by the peoples of Western Europe; hence the extraordinary enthusiasm for war shown by all nationalities at the outbreak. Men flocked in their thousands to join up. Women gave out white feathers to any man not in uniform. This spirit of a distorted patriotism was also much encouraged by the religious bodies, although what business it was of the church, I would have some difficulty in explaining; their only responsibility being the saving of men's souls, not waging war against another Christian country.

Patriotism is certainly not enough. "My country, right or wrong" is, for me, a most repellent doctrine. As citizens of a democratic country and also as human beings, we have the duty to hold our government to account. We must make it clear to them when they propose any change in the law of which we disapprove, both personally and within a group. We now have so much greater access to information, including the ability to watch the House of Commons in session on live TV, that we have no excuse any longer for being ignorant of what is voted on in our name.

"Patriotism is the last refuge of a scoundrel." – Dr. Johnson

"Arbeit Macht Frei" is surely one of the most cynical, ghastly and cruel slogans ever uttered by mankind. It is recorded above the gates through which millions of Jews, Poles, gypsies, homosexuals and the disabled entered. I have no knowledge as to who created it. Following Krystalnacht, the Nazis lit bonfires to burn books of which they disapproved. It was said at the time, that a nation, which burns books, will end up by burning people.

How right that proved to be.

I am quite sure that Goebbels, Hitler's Minister of Propaganda, used those words to persuade all the countless people who walked through those gates, that they were going to be looked after by a kindly German government. The decision had already been taken by the upper echelon of the Nazi party to carry out "The Final Solution", to exterminate the Jews throughout Europe. Goebbels was the man who murdered his six lovely children, all below the age of nine, killed his wife and then committed suicide. How could such words be used when people were being sent to their death? - "Work Makes One Free?" Many millions were never to return.

Seeing the newsreel of 1946 recorded by Richard Dimbleby from the BBC, (one of the first newsmen to enter the camps), with the immediate sight of vast heaps of naked, emaciated bodies of men, women and children, most dead and some on the point of death – as a boy of sixteen, those images are deeply engrained in my mind. Neither Richard nor anyone else was able to comprehend how people could behave in that way towards their fellow man in a modern state of highly

educated citizens, who believed they were being patriotic. That is the ultimate destination of patriotism.

It is still a powerful force in the world.

There were many brave people in Germany who tried to stand against the Nazi regime and its treatment of the Jews. Paul Bonhoffer was one such priest whose courage was remarkable. The film, *Shindler's List,* has shown the world how one man can do things, which help people he does not know, even though he gains nothing from such actions and could be put to death if discovered. The world needs more people like that.

I watched the film of the Nuremberg trial held in 1946 of the senior Nazi leaders, on 5th August 2009 broadcast on Arte, a French TV station. Anyone who still maintains that there was no holocaust – for example, Mr. Ahminejad, President of Iran – should be forced to watch both that and the newsreel by Richard Dimbleby. There would then be no possibility for such self-deception. The films should be shown to secondary schoolchildren everywhere. There might then be a better appreciation as to what may happen to any nation with too much patriotism and religion. Germany, to its credit, has been sending its children on school trips to see the concentration camps for themselves. This has probably been the reason for the whole country to be against allowing their troops in NATO to participate in combat with any other nation.

13.2 Religious Fervour

Christianity began when the Jewish priests persuaded the Roman governor to crucify Christ. Since then Christians have felt it perfectly reasonable, even their religious duty, to persecute the Jews. When the followers of Islam occupied Jerusalem, mediaeval Christians believed that they should fight wars for several centuries, to free the holy city. They even went on religious crusades, taking children with them. The Children's Crusade was one of the most inexplicable events in the Middle Ages. We find it immensely difficult to come to terms with such thinking.

The new religion of Protestantism produced the most rabid response against the Roman Catholic Church and resulted in many desecrations of the statues in both country churches and the great cathedrals. Even the heads of the mother of Christ were destroyed.

This provoked Catholics to retaliate, with Queen Catherine de Medici of France ordering the massacre of St. Bartholomew, where many hundreds of Huguenots were killed. They fled from France and settled in England and South Africa. The Catholic priests who remained in England had to go into hiding, sometimes in "priest's holes", which can still be seen in the great country houses.

Catholics believed they must torture and murder protestants in order to save their immortal souls – and vice versa. It is difficult to understand their rationale knowing Christ's teachings of love and forgiveness, which both sects had promised to follow. Christ is recorded as commending the principle "Love thy neighbour as thyself", certainly a worthy

precept and one which was supposed to have been accepted by his followers.

Most unhappily it was not.

13.3 Xenophobia

I wish I loved the human race
I wish I liked its silly face
And when I'm introduced to one
I wish I thought – what jolly fun.

– Anonymous

It was a major part for the security of a tribe to regard all strangers with the greatest suspicion. This was as necessary as the invention of a god to try to keep its members safe from danger. That time should be long since past, but such teachings are buried so deep within our brains that they are inherently difficult to forget. However, there are good signs that xenophobia will soon be as out of date as witchcraft. The access of travel to foreign parts is now available to many people in the world. "Travel broadens the mind" is an old adage, but remains true today. Our minds certainly need broadening.

The inventions of the computer, the Internet, mobile phones and their international adoption, together with the immediacy of world wide television, (none of which was dreamt of when I was born), must inevitably bring people of all denominations, nationalities and different understanding of the world's situation, together. Never again will it be possible for a British Prime Minister to be

able to say, as Chamberlain did in 1938 when Hitler invaded Czechoslovakia, "It is a remote country, of which we know nothing". I had the pleasure of talking to the son of my cousin recently who is living in Australia. We have never met, but through the magic of the Internet, we were able to converse and see each other for the first time.

One of the unforeseen benefits of the British Empire is that so many of its peoples wish to come and live in the country. London is now the greatest example of a multi-ethnic society, overtaking New York.

More than three hundred languages are in daily use and local councils are responding magnificently to the challenges that this produces. For me, this is one of the most persuasive signs that the world is on the right way forward. Of course it is not plain sailing. We have not yet seen the end of xenophobia. Most underlying and unresolved problems from all cultures and social societies are almost impossible to resolve in the short term. But resolve them we must, if the world is to live in peace and come to understand the other person's point of view.

I have here to cite the "culture of honour" amongst the Muslim society. If an Islamist wishes to come and live in the UK, he will be welcome. But he and his family must accept that there is no place for such an outdated belief in our country. It has taken us many hundreds of years to arrive at our tolerant society and we will not return to the past for anyone. The Muslim will no longer be able to decide his daughter's future. In the United Kingdom, women decide for themselves. Women have won their right of freedom of speech, freedom of thought and freedom of action. I have to take issue with the Archbishop of Canterbury. He is on

record as saying that there is a place for Sharia law in this country. He is wrong. He is bending over backwards to show that the Church of England is a broad church and welcomes anyone. I am astonished that such a priest should even contemplate that women should be subjected to the will of their fathers. That takes us back to the past. He must be aware that there is one courageous Muslim lady who has founded a charity to help women who are being forced into marriage by their parents – in England in the twenty-first century! How does the Church of England answer that?

Extremely religious people, although kindly enough, tend to find it difficult to focus on other, more down-to-earth matters. I am afraid that, in general, they are rather narrow-minded. What is it that persuades so many people that they have a potential saviour? It can only be wishful thinking and the need to escape from their day-to-day existence. Patriotism, xenophobia and religious zeal are all still alive and thriving well in the twenty-first century – and so is war. Both sides to every disagreement between countries must persuade themselves, at the same time, that war is no solution. We must stop believing in it.

Daniel Barrenboim has founded a youth orchestra from both Israelis and Palestinians, who travel together and perform worldwide, - the power of great music bringing people together. If that is possible, it gives us hope that all problems between nations and religions can be resolved.

Chapter 14
The Twenty-first Century

14.1 New York

The date 11 September 2001 changed my view of Islam completely. I had not realised before that there were imams who preached such a violent message of hatred against the West and who were able to convince young men that they would go to paradise and receive several virgins if they died after killing large numbers of innocent men, women and children – even other Muslims. What an extraordinary idea for a religious person to concoct – and even more so, - that it is believed. Such is the power of religion, not far short of the occult.

That afternoon, I was in a large London store in the electrical department, with no one to serve the customers. The staff were all glued to their television, unable to believe what was unfolding before their eyes and neither could I. Two years later in New York, I dined at a restaurant in the Italian quarter. One wall in the entrance was covered with photographs of people who had died in that tragedy, including many young Italian men who had been employed as firemen. They died attempting to save people trapped in the two buildings. I found it intensely moving.

14.2 London

The seventh of July 2005 was another such day in London. Three young Moslems, born in Britain and inculcated with the message of their god's wishes as interpreted by imams, detonated themselves on different London underground tube trains at almost the same time. Another blew himself up on a double-decker bus shortly after. They killed innocent people without mercy, believing that they were carrying out divine instructions.

One week later, a young Brazilian electrician, Alvarez, thought by the security services to be another bomber, was shot six times by police while sitting in a train at Stockwell Underground station in front of a carriage full of passengers. Here the warp and weft of life become brutally apparent. The connection between the two events is inescapable: one followed the other with an inevitable ghastly logic. The policeman had no alternative but to shoot. He was not in a position politely to inquire whether the chap was carrying a bomb. Had he been, the result would have been catastrophic: all the passengers would surely have died.

Alvarez was entirely innocent and most probably a devout Catholic; his mother certainly was and has erected a shrine in his memory in Brazil. Neither the Pope nor Alvarez's guardian angel could save him and his death is yet one more that is the responsibility of Islam and their belief that it was god's intention. This is the madness which religion has brought us to.

The question should be put to those imams: How do they reconcile this intolerance with the requirement of the Quran, that they should be pious, be righteous and fear god?

14.3 Cities

As we have seen from the time of Alexander, there has been the desire for individuals to coordinate his fellow man so that they may live together in prosperity, peace and under his authority, thereby increasing that person's power and prestige. This occurred in different parts of the world at about the same time and resulted in the formation of towns and cities.

They have formed the high point of civilisation throughout history. The major cities in every country provide work, culture, sport, medical care, university education, close-knit social communities and a wide range of easily accessible activities for a complete and fulfilled life for men and women of every age and social class.

Nation states provide none of those things. Their only reason for existence is for our security and to ensure that people are able to live at peace with their neighbours. At the start of the twenty-first century, perhaps politicians are beginning to understand that simple thought, as there has recently been some attempt to devolve power away from central government towards local communities. At present, sixty per cent of the population of the world live in cities. Both China and India are directing a large proportion of the wealth they are creating towards redeveloping their cities to ensure their peoples can live secure lives in decent homes.

The buildings in every city form an historical record of the development of civilisation, which reveals that change and progress toward a better future is inevitable. The attraction of city life is inescapable and will continue.

Chapter 15

The Environment

15.1 London Particulars

In my younger days, I well remember experiencing the London particulars (smog). These were the result of the use of coal for heating in every household, office and power station. Our house had four fireplaces, one in each main room plus the boiler for hot water in the kitchen and so did everyone else. The fireplaces in the bedrooms were never lit or prepared unless the person was ill. There was no central heating, so every morning in the winter the inside of the single-paned windows in my bedroom had turned to ice. My brother and I had to scrape it off before we could see outside. Dense fogs were the inevitable consequence whenever the weather was right for them. At every street corner in central London, there were fires lit because the street lighting was not powerful enough to penetrate. Many people were killed because drivers could not see them. Fortunately at that time there were few cars. My wife well remembered that on one occasion, the fog was so dense that the bus driver went along the wrong street. She had to get out and walk home because the bus could not turn round. Everyone had similar stories; they were part of life's rich pageant.

In one year alone, 1952, doctors certified over forty thousand Londoners having died as a direct result of air pollution. Immediately the government passed a law - forbidding doctors from certifying death from such a cause. They had to record the death as heart failure, so we shall never know how many deaths there were. One of the worst polluters was Battersea Power Station, hard on the Thames in Wandsworth, south London. This colossal building, powered by coal brought up river, had four vast flues, three hundred feet high, which discharged their toxic gases high into the air and right in the heart of the city. It was first fired in 1942 and closed down in 1968 when the government eventually passed the law, The Clean Air Act, preventing coal to be used to produce electricity.

Almost overnight, the London environment changed dramatically. This is proof, if proof be needed, that men and governments are able to bring about the necessary changes and improve everyone's life. We have the intelligence and knowledge as to what needs to be done.

It only needs the will.

15.2 Global Warming

Le Coeur du Monde

La lune regarde la terre de loin dans l'espace
Elle est curieuse et plein de grâce
Encore feminine et belle
La terre semble à elle
Pleine d'arbres et d'oiseaux
De bouquets d'herbes et d'animaux
De poisons entre les mers autour
Le Coeur du monde qui bat partout

Regardez-moi bien, mes amis sur la terre
Je n'ai pas d'arbres, pas d'oiseaux
Pas d'herbes, pas d'animaux
Pas d'eau, pas d'eau, pas d'eau
Souviens-toi de conserver tout autour
Le Coeur du Monde qui bat partout

Pour Lisa, agée neuf ans
Qui dit le mot "Mon Coeur" de façon si belle

– Derek Potter
Luxembourg
November 1998

I wrote this for my granddaughter when I thought that the world was heading for ecological disaster. I hope that Al Gore will forgive me, but I am now not so convinced that it was mankind who has brought about the apparent changes in the atmospheric conditions. We need a lot more evidence, in spite of all the worthy protestations, world conferences of the great scientists from all over the world

gathering together to make their case. Certainly I agree that all options to produce a fuel other than oil must be investigated. Man has always managed to discover new ways of living and this will not be any exception. I am extremely pleased that wind power has been resurrected after all those years. Windmills, colossal though they are, do not, to my eyes, seem out of place in the countryside. I have seen many in France, Belgium and Luxembourg, which enhance the view; they provide an extra dimension, a modern version of windmills in the Dutch landscape and on the Greek islands of the Mediterranean.

The development of nuclear power has arrived at just the right time for the production of electricity, which is so vital for our way of life, just as fire was four hundred thousand years ago. This source of power is the most important to be discovered in the twentieth century. France has been pre-eminent in that development. Living in Luxembourg, just over the border, I can see one station very close to my town. It never gives me the slightest anxiety. Nuclear power was never the cause of as many deaths as the excavation of coal in deep mines by men and even children in the nineteenth century. Today there are still deaths in coalmines occurring regularly in China. At present nuclear power is not economically viable compared to either coal or oil, but that situation will change, given the necessary research and advance in design, which has always happened when a new technology arrives.

Governments and our members of Parliament should widen their perception to understand that they must think in longer terms than the next election. They have been elected to take decisions on our behalf, having all the crucially important information, most of which is not available to the

electorate. They should learn to speak their minds openly and not to wait until drastic action is necessary, - following the examples of Franklyn Delano Rooseveldt, President of the United States during the Great Depression in the 1930s, who said "We have nothing to fear, but fear itself" and Winston S Churchill, Prime Minister of Great Britain. His opening words to the people in the first year of the Second World War were "I have nothing to offer, but blood, toil, tears and sweat". At the end of the war he foresaw that the country would "regain the sunlit uplands". Only by giving the electorate the truth, will politicians be able to regain people's confidence. Too often they are seen to evade giving straightforward answers to questions put to them by the press because they fear that they will offend someone and lose the next election. We have few statesmen these days, but they have always been somewhat rare.

15.3 Ecological Disasters

There have always been natural disasters throughout time. The great flood, Pompeii, Krakatoa, Haiti and the tsunami on Boxing Day 2005, which caused so much death and destruction in Indonesia and as far away as Sri Lanka. This resulted in the immediate generosity of everyone who donated money to ensure that those suffering became aware of that they were not alone in their horrendous situation. The event occurred while I was living in a block of flats in Canary Wharf, the financial district in the East End of London.

Everyone in the area contributed to a disaster fund immediately set up – not because we felt guilt at our

prosperity, but because we felt a great empathy with those people we saw nightly on television. It has been said that a butterfly fluttering in South America can cause a typhoon on the other side of the earth. Some people appear to believe that the tsunami was a direct indication of god's wrath on Islamists who had misbehaved. Both ideas are equally ridiculous, although the butterfly effect is the more romantic of the two. The tsunami was the result of the tectonic plate moving along the fault line deep below the earth's crust.

I am sure that somewhere, a scientist is working on the possibility for extracting heat from the central core. As we have frequently seen, science allied with technology, has the answer to all of the problems for the survival of mankind, except for those caused by the antagonism brought about by differing nation states and religion. There can be no further advance on the road to peace and prosperity for all, until both are committed to the dustbin of history.

15.4 World Population

My grandmother had thirteen healthy children: my parents three. In 1930, when I was born, there were two billion people living on our planet. This has more than tripled to seven billion during my lifetime. Such an increase cannot continue. Earth is finite.

Science tells us that there has been not one drop of water added to the world's supply since it evolved. It is constantly re-circulated and naturally regenerates itself, but it cannot increase in quantity. Humans are 90 per cent water and we need several litres a day if we are to survive. The production of food is also heavily dependent upon irrigation. Water

alone will determine the number of people, which can be supported by the planet. It is already in short supply in many parts of the world, especially in Africa and is yet another subject of violent disagreement between Israel and Palestine. Somehow, the numbers of all populations must decline. In the past this has been effected by the four horsemen of the Apocalypse: famine, war, pestilence and death. Due entirely to the advance of science – and not at all to divine providence – these four factors have been significantly reduced. We have vastly increased the food supply, overcome many of the diseases, which ravaged the world in the past and even increased the longevity of man. Only war itself remains to be defeated.

China has decreed that each family is only permitted to have one child, otherwise they will be fined heavily. This has certainly significantly reduced their population, but resulted in an oversupply of boys, with girls being regarded by the Chinese as an unfortunate necessity rather than a source of pride.

We now know we are alone in our planetary system. There is no supernatural being looking down from above, smiling benignly upon us when we perform a good deed towards our neighbours, or grimly wagging his finger at us whenever we disobey his commandments. There is no one collecting all our misdeeds for some evaluation on the day of judgement; no one is above who will respond to our prayers and make the world safer, more productive and happier.

We must learn to become totally self-reliant.

Chapter 16
Conclusion

16.1 The Common Threads of Mankind

A young girl died on her sixteenth birthday in a coach crash in Cumbria. I turned eighty on almost the same day. Did god decide that she, at the start of her young life, would die and that I would live to a ripe old age? One only has to pose the question to any religious person, for them to realise that it is nonsensical. Life is immutable; events happen without reason.

Religion was, without doubt, essential for our survival initially and preserved the primitive way of life, allowing society to develop to the present time. But we now understand so much more about ourselves - and our world. Many questions remain to be answered, but the outlines are clearly established. Religion has served its purpose. Its shortcomings are likely to bring about disaster if it is allowed to continue to occupy a central part of our lives and dictate the future. No longer is it one of the common threads of life. It only stands in the way; it divides and does not bring people together. Religion teaches us that it is a virtue to be satisfied with not understanding – to follow without question that which we have been taught since our childhood. The world of science and technological innovation moves swiftly.

171

The world of politics and international affairs moves rather slower. The world of religion moves not at all. In the twenty-first century, we are surely better equipped to confront our problems on our own and understand how we are able to succeed, without outside help.

Having been fortunate enough to live and work on both sides of the equator; in temperate and tropical zones; on three continents; in five countries with disparate forms of government, social customs and religions; I believe that the one unique factor in the common threads of life were the people whom I came to know. Without exception, I have never had any difficulty in forming good relationships, often lasting friendships and have much enjoyed the diversity of life everywhere I went. These are lasting memories and are the reason for this attempt to make some sense out of my time here on earth.

Another of the strongest threads which will come to bind us together, may yet prove to be the English language. Spoken in Great Britain, the United States and many other countries, it is used because it is the easiest in which to communicate basic information accurately, as in the aviation industry and text messages.

It was not forced upon people by the power of any state, but has evolved naturally in response to a great need. China requires their students to study it as a second language, as do most European schools. Direct and comprehensible communication between politicians of all nations is essential, if we are to avoid another world war.

All of us must come to realise that we should no longer follow religious dogma, but rather those values which Christ and Omar Khayyam stood for. We should enjoy our lives

while we have our time here on the earth – and especially, to do what we can to help our fellow man.

16.2 The Values of Working Together

Our future lies solely in the knowledge that mankind must work together to solve our problems; such has been said and written many times before, but now there is no alternative. The possibility for some nation, under the guise of messianic zeal, to attempt to preserve its unique faith (and who has the potential to use nuclear weapons), is now so dangerous that we are standing on the edge of a precipice. Most people on this planet, with their electronic methods of instant communication, are aware of this threat, but they feel powerless to prevent it. We have the experience of the past upon which to draw and the self-confidence to succeed. Unrealistic beliefs only clog up our understanding and prevent our working together.

Those magnificently decorated Greek vases produced in the fifth century BC, are much admired throughout the world and collected by all the great museums. They have never been equalled, let alone surpassed. They were not produced for use; there was only one purpose in the mind of the man who made it. He wanted it to be supremely beautiful. Man's hand, man's eye and man's mind have conjured up a thing of such beauty and originality, as to demonstrate beyond question, that he is the one civilised and intelligent creature on this planet. I own a Roman pot, which unearthed by a Victorian archaeologist and was purchased for a nominal sum at Sotherby's auction. It is small and undecorated, produced simply to hold water or wine, but it

gives me the greatest pleasure to hold – being able to touch the hand of the man who made it and those who used it, two thousand years ago.

In modern times, man produced another object of great beauty. This time it was to be of use and required the collaboration of many different people, designers, engineers and technicians, even two nations: the French and British. Neither country could have afforded it separately, but together they succeeded.

It took many years, but eventually Concorde flew. It was a magnificent achievement. I remember she flew very low over the town of Bromley, in south London where I lived, every evening at six o'clock, on the way to land at Heathrow. The town square was filled at that time with people shopping or on their way home. Without exception, they all looked up to watch her, no matter how many times they had seen her. No other plane could cause such a reaction.

This is surely the way all nations should work together, to achieve something for which they wish but cannot do so individually.

Europe, with its different nationalities and for its entire existence, has produced the majority of the good things of life for everyone on the planet – in science, art, medicine, philosophy and inventions of every sort – and will continue to do so. In this sense, Europeans seem to me to continue on from the Ancient Greeks, - to concentrate upon creating original ideas and exploring unknown territory. The Americans, on the other hand, are the action men of modern times, as the Romans were before. They take ideas and push them to the limit. The world needs us both.

My wife and I lived for four years in Luxembourg, during which time we learnt to appreciate the European view of life and of the importance of people being able to forget the past and work together for the common good. After all, it had only been a relatively few years since the Nazi party had conquered and ruled dictatorially over the rest of the European nations, causing bitter feelings between them. Now all was forgiven, although not yet forgotten. The creation of the European Union after the Second World War, from countries who had fought against one another for so many centuries, will bring about a vital force and give a lead to everyone else, as did the United States of America in 1776.

There is one reason for many of the British people to feel uncomfortable with the founding of the European Union: they believe that Europe has taken away a large part of their sovereignty. This reaction is understandable at one level, but will change when the benefit of working together at peace with our neighbours becomes clear. The European Union is still embryonic and imperfect, but over time, it will change for the better. Even so, it is able to attract new countries who wish to join, notably Turkey. This is most encouraging news and should be accepted with alacrity. I am aware of the concerns voiced by Germany about the possible influx of immigrants, which will happen as a result. The fact that direct contact will be made with an Islamic nation is too valuable to ignore. This may be the one opportunity, which will produce an understanding of the problems that the Middle East faces. Talking together is the only answer.

Photograph of Bleriot's plane

Bleriot's plane flew across the Channel in 1909 at 30 mph.Concorde crossed the Atlantic sixty-six years later, at the speed of a bullet, due solely to the advance of technology and different peoples working together.

Photograph of Concorde

Nation states will largely lose their power to control their citizens. Undemocratic governments, however regressive, are less able to act alone than before. They are now immediately aware of what the world at large thinks of their actions and cannot prevent their peoples from talking together and exchanging information with other countries. Democracy will inevitably become the norm, not because it has been forced upon a country by pressure from without, but solely due to the demands of the people themselves, as has always happened in the past. We have seen recently that even China and Burma have had to take much greater account of the opinion of their people and allow more freedom to them than heretofore. The Burmese generals have released the campaigner for democratic freedom, Aung San Suu Kyl, from her house arrest after twenty-one years, - following the first election, undemocratic though it was. They had her husband killed years before, but now realise that that option is no longer available to them.

A body of economists have started discussions as to how a new world currency could be developed, following on from the Euro. They believe this is urgently needed, while the memories of the collapse of the world's financial markets is still fresh in our minds and before the next bubble can form.

The new coalition government of 2010 between the Conservative and the Liberal Democrats – the first time that Britain has had such a government since the Second World War – has the potential to effect a radical reorganisation of the whole system. Amongst other proposals are: altering the electoral system, reducing the number of MPs and making the boundaries of Boroughs more equal in numbers of electors. It is to be hoped that the coalition will result in the

best politicians of the two parties learning to work together for the benefit of the whole country – the highest common factor rather than the lowest common denominator, which we have experienced in the past.

During the recent turmoil concerning how parliamentarians are recompensed for the work they do in representing their constituencies, all parties seem agreed that Parliament must be significantly brought up to date. This will also change the House of Lords, perhaps even bringing that ancient body into the twenty-first century with elections of members, rather than the Prime Minister's personal choice.

16.3 Present Dangers

The world situation is far more precarious than during the Cold War, when Russia and America glared at each other across the North Pole. Then it was only two different versions of government at stake.

The addition of religion has far more potential for disaster. One country may feel so threatened that it thinks it is essential to make the ultimate "pre-emptive strike". That will inevitably involve us all. Today's problems caused by rogue states such as North Korea, Iran and Israel are by far the most dangerous elements we have to face in the immediate future. Israel in particular has had the most traumatic history of all nations. It is no wonder that it is behaving so intransigently at the present time, given the way all other nations have treated their peoples down the centuries. We must all realise, especially the Arab countries, that Israel desperately needs security above all else. They have been taught from the beginning of their civilisation –

and have learned their lesson well – that their very survival is problematic and can only be provided by themselves.

The Israeli government claims they wish for peace, but their actions often belie their words. Building settlements on land that was previously the territory of the Palestinians, can only antagonise their neighbours. The Americans say they are working for a two-state solution of Israel and Palestine, but that seems hopelessly optimistic, - with Gaza, both physically and politically, cut off from the West Bank. The situation would be bad enough if it were solely a geographical problem; with the addition of the religious divide, including the intractable problem of Jerusalem, it would seem to be almost impossible. The situation between Israel and Iran, – being of the same racial background, but of different religions and both having a potential nuclear capability – does not bode well. Egypt showed the way forward for the other Arabic nations, when they signed a peace treaty with Israel at the end of the six-day war in 1967. It is just possible that Iran will decide to follow their example and regain the trust of the West.

We can only hope against hope and try to give both sides confidence that help will be forthcoming from the entire world, if they can reach agreement; prayer to the almighty, on whichever side of the fence he is, would be quite useless.

Murmurs have been heard from certain quarters, that the West should talk to the Taliban in Afghanistan. I am entirely in favour of such an approach. At the very same time, we are refusing to engage in any way with Hamas, the organization elected by the people of Gaza. Not only is this completely inconsistent, but futile. How can we get people to change their minds unless we talk to them?

These problems must be solved very soon, although at this time, it is impossible to say with certainty how the parties will be able to come to their senses and resolve their differences. I do not believe that anyone else can do it. The imposition of solutions by other countries has been tried too often in the past with no success.

Now the United States has President Obama, midway between a Christian and a Muslim. He is, therefore, uniquely placed to mediate between the two religions. His response to the problems, which Israel poses, is also of great difficulty to him. We know that there are as many Jews in America – forty million and all with a powerful vote – as there are in Israel.

Obama is caught between the rock of Islam and, in his case, two hard places: Christianity and Judaism. Perhaps, because of this, he has the potential and is the best placed of all leaders to guide the world into a new age.

We are anxiously waiting to see.

16.4 The Future

In 1961 my daughter was born, in the same year as the Russians built the Berlin Wall. In 1989, my granddaughter was born, in the same year that the wall was pulled down. Communist Russia fell with it.

Walls are still being built: in Israel to divide the Palestinians and in America to keep out the Mexicans. The reason for their erection is understandable, but we must realise that, in the long run, they are ineffective. When the wealth of nations

is increasing and has become more evenly distributed, there will be no need for people to become so desperate that they will face any danger to go where life is better for themselves and their families.

Apartheid in South Africa fell too. It was not brought down by pressure from religious organisations, which had for years preached against its injustice. It came about when three hundred major trading companies from the United States, Great Britain and Europe simultaneously withdrew from the country. This eventually followed on from the Sharpeville massacre in 1960, which horrified the world. No government, however dictatorial, can stand against a massive withdrawal of finance. Is not this the way change should be brought about in future, without the devastation, which inevitably results from invasion by armed forces?

It is time for religion and the concept of the nation state to fall as well.

All religious organisations have programmed themselves and their followers to believe in the unbelievable, in order to have authority over the rest of us. They appear not to have the slightest confidence that man can solve problems on his own – problems to which the religions have often largely contributed. They continue to offer prayers for salvation. Are they able to give one instance of such prayers being answered?

Come now; let us together unshackle the yoke of our own making from around our necks, the yoke of religion. It has directed us to only one destination: that of servitude to a god who does not answer our prayers and, we now have come to realise, does not exist. Mankind without religion and with the collaboration of democratic governments will then - and

only then, have a much better understanding and be able to control his destiny entirely on his own. There never has been anyone else.

We shall still have the capacity to marvel at the works of the past. To stand in wonder in the Sistine Chapel and gaze at the story of Genesis as portrayed by Michaelangelo: to listen to a great performance of Handel's *Messiah* and absorb the immensity of the constructions of the great Gothic cathedrals. They are overpowering, constructed by builders who believed that they were working in service to the majesty of god. We shall see them instead, as a revelation of the stature of mankind.

The satellites show us that earth is very small, a spaceship hurtling through the solar system controlled on its path by the sun (the Ancient Egyptians understood the crucial importance of the sun), the one planet, which can support life. This appreciation has come at just the right time in our history. In the near future, the world will be a very different place. China and India will lead, as the United States did in the twentieth century and Great Britain in the nineteenth. They made the world richer through free enterprise and trade. We hope that China will do as well. Together we can solve all those economic and social problems, both those which we now face and those which will come upon us in the future. There is no other solution.

Throughout that long history, mankind has felt the need within himself to achieve his ends, whatever they might be - and hence, to obtain satisfaction from those achievements. Both men and women have always been strongly driven to succeed in whatever they set their hands to. This is the only reason for our survival. We are free men and women, able to

decide for ourselves who we are, from whence we have come and to where we are going. Our destination is, as it always has been, - the future, - above all, for our children. There is no future in the past.

That is why we are men and women; we have been programmed to procreate and certainly not to believe in the unbelievable, not to believe in anything, but how we can organise ourselves to overcome those apparently intractable problems which have bedevilled different countries, different religions, for centuries – one religion, one country, one culture against another.

We have fortunately been granted intelligence – or rather, we ourselves have developed it throughout time immemorial and certainly for the last four hundred thousand years – to determine our own destiny.

There is no one else to hold to account. If we destroy our species as a result of one religion being antagonistic against another, one country against another, it is only mankind who will perpetrate that last scenario. It will not be as a result of god's wrath being inflicted upon us.

No man is an island entire of itself
Each is a piece of the continent
A part of the main
If a clod be washed away by the sea
Europe is the less,
As well as if a promontory were,
As well as if a manor of thy friend's
Or of thine own were.
Every man's death diminisheth me
Because I am involved in mankind;
And therefore never send to know
For whom the bell tolls:
It tolls for thee.

John Donne
Dean of St. Paul's
1572–1631

Lightning Source UK Ltd.
Milton Keynes UK
171757UK00001B/5/P